CHILD PHOTOGRAPHY

Bernard Fearnley

FOCAL PRESS London & New York
Distributed in the U.S.A. by
AMPHOTO, 915 Broadway, New York, N.Y. 10010

CHILD PHOTOGRAPHY

Amphoto ISBN 0–8174–0794–4
Library of Congress Catalog Card No. 76–186991

*Printed in Great Britain
by W & J Mackay Ltd, Chatham*

To my wife and help-mate

Contents

Introduction

Children are all around us – laughing, playing, and discovering a strange, exciting, but sometimes frightening world. What a subject for the camera! It takes the newest art to do it justice.

Children are people

What camera owner has not tried to photograph a child? From the very outset, working with the simplest camera, children are the favourite subject. Probably more pictures are taken of children than of all other subjects put together. The new baby in the family is often the reason for buying a camera in the first place. Hundreds of thousands of feet of film are exposed on children every year. Where, then, are all the masterpieces? Where are the pictures adequately portraying the varied facets of this fascinating subject?

Thousands of child pictures are proudly displayed or projected for the polite approbation of friends. How many are more than snapshots? A handful reach the major exhibitions, or are used in advertisements, or win competitions. Most fail to catch more than a mere record of the child's features.

It is easy to photograph a child. Just point your camera in the right direction and shoot. But to get that extra ounce of life and personality into the picture requires a good deal of effort, forethought, patience, skill and know-how. If you are a proud parent with your first camera recording your child's progress for posterity, an advanced worker aiming at club-competitions and later perhaps the 'Salon' or the 'Royal', a student wishing to master this difficult branch of photography as part of a comprehensive course, or a professional whose job occasionally calls for photography of children (say photo-journalism or advertising), then you have probably something to learn from the top photographers specializing in this aspect of the craft.

Our grandfathers had to struggle with cumbersome equipment and slow materials. Their children were of the 'seen not heard' variety, now largely extinct. Today the pendulum has swung the other way. Modern techniques enable us to catch and hold a thousandth of a second, or a millionth, if we wish. But the children, ah, that is a different matter. With less parental control and the shedding of inhibitions, children tend to get more difficult to handle. And this aspect of child photography, involving a working knowledge of psychology assumes the more important role and is dealt with in some depth in the following pages.

The child you are to photograph might be friendly and cooperative. On the other hand, he might be a bundle of suspicion. But in the space of a few minutes you have to win him over and get a response that reveals something of his true character. Technique has to be so mastered that it can be relegated to the back of the mind, freeing you to devote most of your energies to handling a small but extremely sensitive and complex human being. To many, this is the most difficult photographic task. Each child is a separate challenge.

Those of us whose job involves photographing thousands of children in the course of a year, find the task wearing on nerves and equipment, but immensely rewarding. Perhaps the most important point to remember is that it is essential to be sincere and to treat children as real people. You should be able to project yourself into the child's world of make-believe, be prepared to bark like a dog or carry on a conversation with a puppet or generally make a fool of yourself. It also helps if you are a little mad.

You will certainly never stop learning about children.

Much having a bearing on successful child photography, in or away from the studio, is set down here, including notes on the mysterious and much misunderstood paths of psychology.

1 Historical Background

Children grow up too quickly. Parents have always longed to slow the process of 'growing up', to hold particular moments of 'fleet childhood' to cherish in later years. Photography, which can do this, is so commonplace a part of our lives today that it is difficult to imagine a world without it. Without the family snapshots, school groups and studio portraits to stimulate our memories, would we really be able to remember exactly how our children looked in their infancy? A certain expression or attitude caught by the camera can start off a chain reaction of priceless recollections. Yet it is almost certain that more recent impressions of our children would obscure the earlier images, were it not for the camera.

Influence of painting

Before the invention of photography, only the well-to-do were able to indulge the desire to hold captive, moments of their children's lives. For instance, John Drummond, who arrived in London almost penniless in the eighteenth century, but later founded a bank and made a fortune, was not a patron of the arts in the accepted sense, yet he commissioned paintings from such eminent artists of the day as Reynolds, Zoffany and Raeburn. These great men were employed to make portraits of the family, individually and in groups, in much the same way as a professional portrait photographer would be engaged today.

The earliest photographers were often artists using the new medium to help them with their paintings. One of these was David Octavius Hill, who, ironically enough, is today remembered for the excellence of his photographs, some of which were of children, while his paintings are not now highly valued. Some artists did not expect the new invention to last. One of Daguerre's backers is said to have remarked, 'One is little disposed to admit that the instrument [the camera] will ever serve to make portraits.'

Some artists saw a profitable future in photography, some, playing safe, became 'artist-photographers' dabbling in both media. Delaroche, said, 'From to-day painting is dead', and many, indeed, believed this to be the case. Unfortunately, during a large part of the nineteenth century many photographers were preoccupied with imitating paintings. Backgrounds, posing and lighting were influenced by the accepted painting styles. Even Julia Margaret Cameron, who had produced camera portraits of children to compare favourably with the contemporary paintings without imitating

their styles, later resorted to painterly tricks to produce pictures illustrating scenes from the Bible or the classics. She often used children in costume for these pictures, which, dripping with Victorian sentiment, sometimes bore such titles as 'Pray God bring father home safe'. Even in this century the child portraits of Marcus Adams conveyed a mood (partly by means of an artificial landscape setting) reminiscent of English painting of the Georgian period. It must be admitted, however, that his prints had great charm and since as a court photographer a high percentage of his young sitters were drawn from the aristocracy, his work was doubtless appropriate to hang on the walls of stately homes alongside the ancestral paintings. Artists and photographers have continued to influence each other's work to this day, but it is only comparatively recently that photography has been recognized as a separate art expression which can stand on its own without necessarily acknowledging any allegiance to those with a longer tradition.

Insight and the camera

Someone viewing an exhibition of child portrait paintings might ask if this is an instance where the painter's personal insight can beat the photographer's superficial accuracy. This presupposes that photographers are incapable of insight. In earlier days when photographers were shackled by the limitations of their materials and equipment it was inevitable that technical considerations would predominate, and yet some very beautiful and sensitive portraits were produced by some of the earliest photographers. Today, freed from technical uncertainty, the photographer must cultivate a perceptive eye, observing the child's reactions and expressions.

The child must be allowed to reveal his personality. Modern technical methods enable you to *hold* the magic moments. You need to anticipate and to act with quick reflexes, still. But now you can pick the fraction of a second you consider to be the most revealing, the most interesting, the most amusing.

The artist, however, has always been handicapped by having to keep his subject still, not just for seconds but for minutes or hours. The lively modern child is extremely difficult to get on to canvas and results tend to look wooden, as were most of the early photographs. There are exceptions, of course. There are also plenty of uninspired child photographers. But I feel that the best camera portraitists produce work that not only shows

evidence of sensitive perception and insight but also shows a true likeness –
which sometimes eludes the portrait painter.

Beginnings of photography

Artists used the camera obscura in one form or another since at least the
mid-sixteenth century to assist them with drawing landscapes. But creating
the image was one thing. Chemically fixing it, was quite a different problem.
In 1826, Nicéphore Niépce loaded his camera with a pewter plate coated
with bitumen of Judea. He set up the camera at his attic window near
Chalon, leaving it exposing all day. When he washed the plate in petroleum
and lavender oil, an image of the barn-yard remained – the world's first
surviving photograph taken with a camera. Niépce died practically unknown
but the man with whom he later associated, Parisian painter Louis Jacques
Mandé Daguerre, probably benefited from his experiments and worked to
improve his own process. In 1835 the Englishman William Henry Fox
Talbot produced a new process using intermediate paper negatives. Two
years later the first daguerreotype was produced. In 1839 Monsieur
Daguerre's process was announced to the Academy of Sciences, Paris. At
last a moment could be held for ever. But, perhaps 'moment' is hardly the
correct word, since exposures of half an hour in bright sunlight were
necessary.

Working with early processes

A grotesque self-portrait of Henry Fitz, jun., with mask-like face and closed
eyes, taken about 1839, is believed to be the oldest surviving photograph of
a face. It is inconceivable that even a Victorian child of greatest obedience
and fortitude could be expected to submit to the ordeal of photography yet,
but some early pictures of sleeping children and even of dead ones, clutch-
ing Bibles, survive.

The introduction of the Petzval lens about 1840 coupled with other
improvements enabled exposure times to be reduced to less than a minute.
Daguerreotype studios sprang up everywhere, enjoying considerable success
for twenty years. But the main drawback of the process, that it produced
only one original, eventually caused it to be replaced by negative-processes
allowing a number of copies to be made. The first of these was Fox Talbot's

calotype. An early photograph of Fox Talbot's children survives, their faces completely obscured by the brims of large bonnets. This method, slower than Daguerre's, required an exposure of five minutes at $f8$ in strong sunlight. It also lacked sharpness. But in the hands of some workers, particularly D. O. Hill and his partner Robert Adamson, some of the finest photographs were made.

In contrast to daguerreotypes, which were small with fine detail etched on to a glass or metal surface, calotypes gave a broader, pictorial effect, which Hill and Adamson exploited, using the grain, the softness and the heavy chiaroscuro to produce a tremendous emotional force. Children figured quite often in their work, in picnic scenes and individual portraits, sometimes in the Scottish countryside.

Some early photographers became itinerant, wandering about Europe with a hand-cart known as a sun-car, loaded with equipment. Occasionally these nomadic photographers would be called to a royal court to explain the mysteries of their process and to take portraits. Thus, some of the earliest child portraits would undoubtedly be of little princes and princesses, whose training for high position would fit them to face, without flinching, the rigours imposed by the camera.

In 1851 Frederick Scott Archer produced the wet collodion process, using a glass plate treated chemically to make it light sensitive. It had to be exposed while it was still wet. Since photography out-of-doors with this method required a cart-load of paraphernalia to be carried including a dark-tent for the coating of the plates and their immediate processing after exposure, it was often considered more convenient to work in a studio, especially if photographing a child. If the child moved during the exposure, more plates would have to be prepared in the darkroom before further attempts could be made.

Early photographers of children

Towards the end of the nineteenth century most professional portrait photographers used the collodion process or its cheap ambrotype variant. Portraits were now within the reach of the poorer people. Since the family as a unit was all-important, groups tended to predominate with 'seen-and-not-heard' children rather overshadowed by imposing adults and surrounded by the status symbols of the day, the draperies and ornamentation

intended to convey the impression that the family enjoyed a life of considerable affluence. In fact, they were probably wearing their only respectable clothes and had probably had to save up for the photograph for quite some time. Partly due to limitations of materials and equipment and partly due to an awareness of the importance of the occasion, children in photographs tended to appear stern of countenance and anxious not to earn parental disapproval.

André Adolphe Disderi, famous Parisian photographer, started the carte-de-visite craze by taking eight pictures on one plate. His portrait of Napoleon, and later E. Mayall's carte-de-visite portraits of Queen Victoria, Prince Albert and children, began the fashion of exchanging cartes. Portraiture, stiff and stereotyped had come to the masses and most of it was shallow and unimaginative.

The work of a few photographers, however, stood out from the mediocrity of the majority, and although they often concentrated on recording the features of the famous – the poets, writers, scientists, artists of the day – they also occasionally took portraits of children which showed them as real individuals with their own personalities, in contrast to the imitation adults who stared out from most of the daguerreotypes made in the commercial studios. Nadar in France, reluctant at first to forsake painting for photography but later a pioneer in many aspects of the new art, Mrs. Cameron and Lewis Carroll in England, deplored the shallowness of the average child photograph. Viscountess Hawarden's photographs of children showed a freshness of outlook and were admired and collected by Lewis Carroll. Charles Nègre's child pictures, in particular his chimney-sweep boys, although necessarily contrived, have a naturalness which suggests they might have been taken with a modern miniature camera.

Frank M. Sutcliffe (1853–1941) has also left us a legacy of delightful pictures which bring alive the period in a fascinating way. His pictures of the lovely old town of Whitby always include figures, carefully arranged and yet with a naturalness and freedom which are remarkable considering the difficulties he had to face. Here are harbour scenes and pastoral scenes, beach and cliff-scapes. We see the narrow cobbled streets and the winding stone steps up to the Abbey. The composition is always perfect with figures to add interest – bearded fishermen, farm-workers and old women sitting outside their doors in what seems to have been a perpetual summer. But what we notice most are the children. Can these be the same children that

sat stiffly in their Sunday best for the family album? Sutcliffe's children are *real*. They live still in his pictures – ragged urchins with patched trousers looking over a harbour wall. A group of boys, naked as the day they were born, bathing in the Esk. Little girls in long dresses helping on the farm. Grinning boys on fishing expeditions. These children enjoyed life in spite of the patches on their clothes.

Exposure time

Any historical survey concerned with photography of a subject as animated as children must keep returning to the matter of exposure time. As, with each succeeding generation, children become less inhibited, livelier, more difficult to control, we are increasingly aware of the need for shutter speeds of extremely short duration. A child offers a succession of fleeting and subtle changes in a rapid and never-ending kaleidoscope of expression. Selecting the right moment and catching it calls for intuitive action, an instant communication between eye and brain and finger and an instrument that obeys in a split-second. Ideally, snatching a moment to preserve on film would be as simple as blinking an eye.

Even though Victorian children were more strictly controlled than the children of today, were they really as serious and prim as they appear in old photographs? How much of their apparent gravity was due to the limitations imposed by the need to keep still during lengthy exposures? The work of Sutcliffe and others shows us that children of a century ago were capable of enjoying life. If modern high-speed materials and shutters had been available to the Victorians, might not our impressions of the children of those days be quite different? Might not Lewis Carroll have photographed his Alice dancing through the woods instead of in quiet repose? Might not Mrs. Cameron have caught a child jumping for joy? Did children of those days never laugh or cry or be mischievous? Of one thing we may be certain. It would be impossible to keep children of today perfectly still for a seven-minute exposure as Mrs. Cameron did.

She chose to give exposures of this length, even when commercial studios had succeeded, by using diffused light from all sides, in reducing exposure times to a few seconds. She abhorred the characterless results thus achieved. Her glass house studio was fitted with roller-blinds enabling her to control the light, so that it came only from the side or the top, lighting each subject

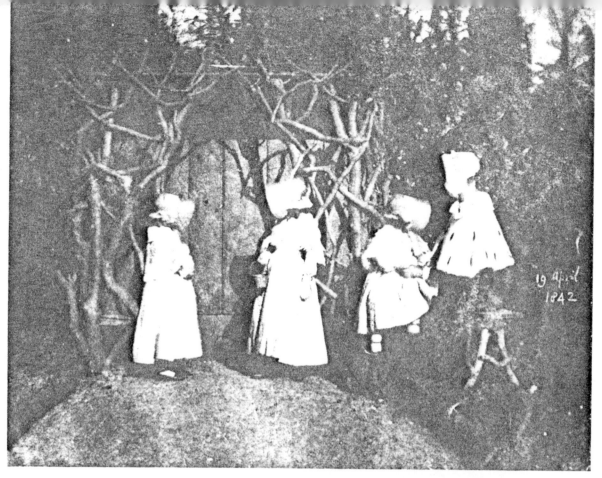

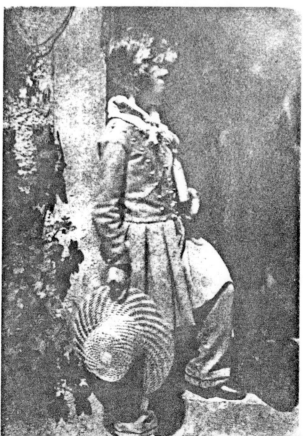

Early child photographs
(*Top*) A calotype taken by Fox
Talbot of his children, dated
1842. *Science Museum,
London, Britain.*

(*Bottom*) Master Hope Finlay
a calotype by David Octavius
Hill, taken between 1843 and
1848. *Victoria and Albert
Museum, London, Britain.*

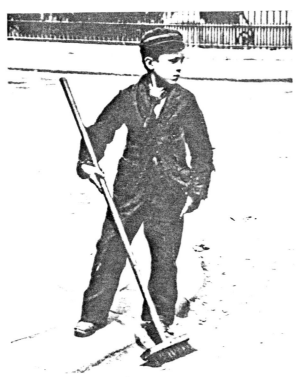

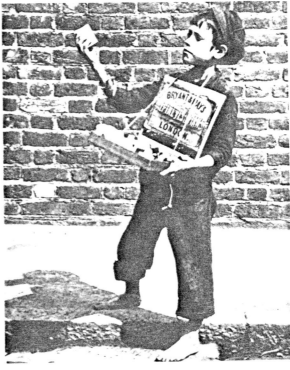

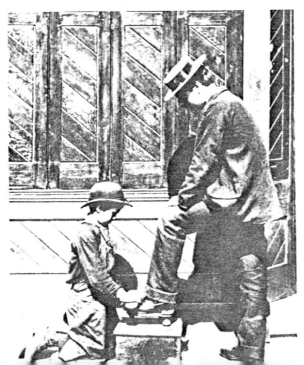

"Grandfather's London."
Three pictures by O. J. Morris
from his book of that title,
*Putnam & Co., London,
Britain.*

(*Top left*) *The Crossing
Sweeper.*

(*Top right*) *The Match Seller.*

(*Bottom*) *The Shoe Shine
Boy.*

(*Right*) One of F. M. Sut-
cliffe's delightful pictures of
Whitby children. *Sutcliffe
Gallery, Whitby, Britain.*

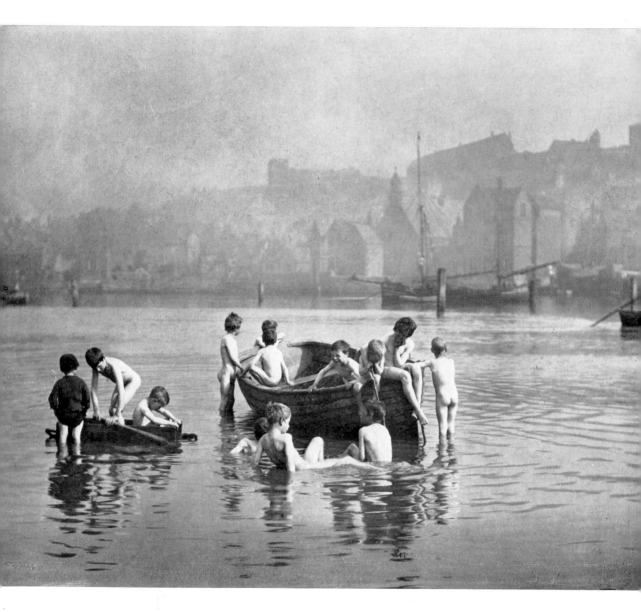

(*Left*) In contrast with the
stiff conventional Victorian
portraits, the pictures of
F. M. Sutcliffe, showed
natural children enjoying life.
He lived from 1853 to 1941.
*Sutcliffe Gallery, Whitby,
Britain.*

(*Above*) Sutcliffe's most
famous picture, *The Water
Rats* taken in 1886. Basically
an arranged composition, but
caught at the precise moment
the boy on the left was climb-
ing out of the box. *Sutcliffe
Gallery, Whitby, Britain.*

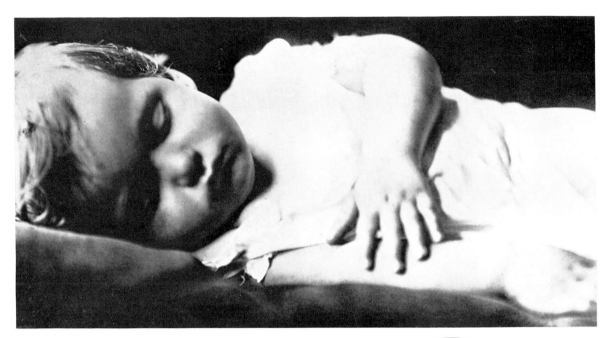

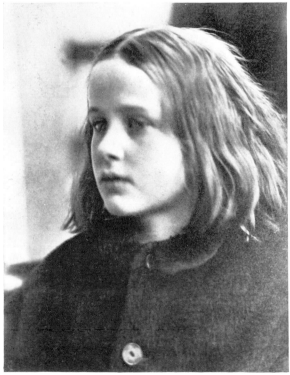

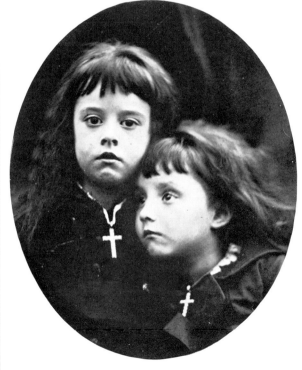

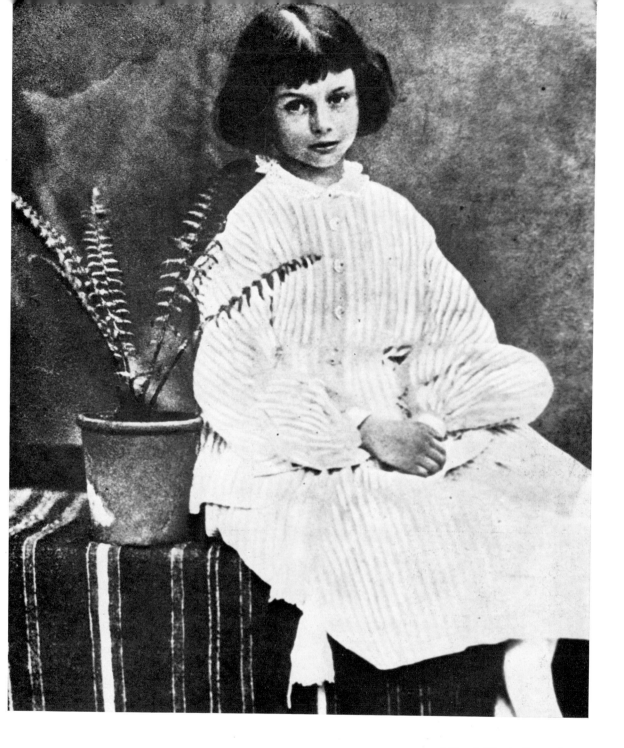

(*Top left*) My Grandchild by Julia Margaret Cameron. *Royal Photographic Society, Britain.*

(*Far left*) Annie—My First Success. Julia Margaret Cameron 1864. *Royal Photographic Society, Britain.*

(*Left*) An albumen print from a wet collodion plate. Julia Margaret Cameron about 1870. *Kodak Museum, Britain.*

(*Above*) Alice in Cameraland. Lewis Carroll's portrait of Alice Liddell, his model for the famous nonsense books. Carroll, whose real name was Charles L. Dodgson, an Oxford don, was probably the best photographer of children in the 19th century. *Science Museum, London, Britain.*

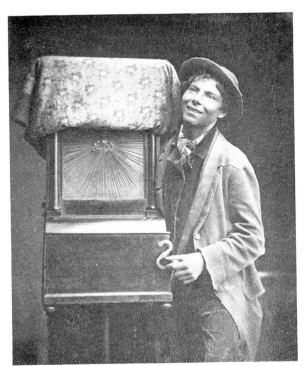

(*Top left*) Penny, Please, by
O. G. Rejlander. *Royal
Photographic Society, Britain.*

(*Top right*) Poor Joe, by
O. G. Rejlander. *Royal
Photographic Society, Britain.*

(*Left*) Innocence, by P.
Delamotte. *Royal Photographic
Society, Britain.*

individually. But the resulting low light intensity, coupled with her insistence on using plates nine by twelve inches or even twelve by fifteen inches, made long exposures necessary. But the results were far superior to most of the professional studios and she is accepted today as the most brilliant portrait photographer of the mid-nineteenth century.

It is interesting to note in passing that even before Mrs. Cameron took up photography, Fox Talbot had laid the foundation of electronic flash by using the flash of an electric spark to photograph a page of *The Times* fixed to a rapidly revolving wheel. The flash duration was said to be 1/100,000 of a second.

Since the early days of photography, the 'instantaneous' picture had been a dream. Since that first success of Niépce which had required eight hours' exposure, times had gradually reduced. Early daguerreotypes had required half an hour (but less later on) calotypes several minutes, collodion about ten seconds. The invention of the dry plate by L. Maddox in 1871 reduced exposure times further. Eadweard Muybridge claimed exposures as short as 1/10,000 of a second in his experimental photography of moving animals and people. His first attempts with dry plates, using forty cameras, a Dallmeyer lens and an electro-magnetic shutter were revolutionary, revealing to painters that their conceptions of the positions of limbs in movement had hitherto been erroneous. Among later experiments he was probably the first to photograph children actually walking and running.

How did photographers keep children still for long exposures? Fear, doubtless played a part. Max Dauthendy tells us that when his father, a popular photographer about 1840, reappeared from under his black cloth, with his hair standing on end, children thought he had been wrestling with a mystic spirit under the cover. They fled with terrified screams.

Being photographed by Mrs. Cameron must have been a frightening experience for children. When at the age of 48 she received a gift of a camera and processing equipment from her daughter and son-in-law, she threw herself into her new hobby with characteristic gusto, turning her coal-house into a darkroom and a glazed hen-house into a studio. Soon the whole routine of her house was thrown into chaos. Servants and visitors and their children were pressed to act as models. The lawn would be littered with printing frames. The smell of chemicals pervaded the air and everything had to stop while Mrs. Cameron flowed a varnish on to a plate in front of the fire or performed some other tricky photographic procedure.

Her studio was untidy and uncomfortable. It contained none of the osten-
tatious trappings common to most studios of the day – merely a chair and a
dark curtain. It is easy to imagine the trepidation of children who were
dragged into the studio by this short, squat, formidable, enthusiastic
woman of eager face and piercing eye, her fingers stained and her dark
clothes reeking of chemicals.

She would pose the children, trundle up her great camera with the
enormous 'eye', and after shouting at them not to move, disappear into her
darkroom to prepare the plate. What agonies of conscience must have been
experienced in the mind of a child who failed to suppress a peremptory
blink or sneeze in her absence. Surely, incarceration in the mysterious dark-
room must be the consequence of such an unforgivable act?

When Mrs. Cameron reappeared she would tell the children that they
could breathe normally during the exposure, blink if it was imperative, as
long as they continued to stare at the same spot. As minute after slow min-
ute ticked by, the child, fearful of earning Mrs. Cameron's displeasure,
would stare with eyes that seemed to be popping out of their sockets. And
if the first plate proved unsuccessful when developed, the whole proceedure
would have to be repeated.

In 1864, Mrs. Cameron was so delighted with the photograph she had
just taken of the small daughter of one of her servants that she rushed round
her house searching for gifts to shower on the child. She printed and framed
the picture straight away and gave it to the child's father. It was inscribed:
'Annie – my first success, 1864.'

Psychology

Photography and psychology, acknowledged to be complementary in the
successful practice of child portraiture, may both be said to go back to
Aristotle. Although the Greek philosopher described a camera obscura in
his book *Problemata*, and the essentials of photography were thought out
by the mid-eighteenth century a fixed photographic image was not achieved
until 1826. Similarly, child psychology as a separate study is not much more
than a century old, although it received detailed examination in Rous-
seau's *Emile* (1761). Thus the twin sciences have had a parallel history and
are comparative infants, as we know them today.

In the early days, portrait photographers were too preoccupied with

technical problems to give much attention to what we should now term a psychological approach to handling children in front of the camera. The limitations of the medium made it necessary to instruct children merely to stare 'straight into the box'. But in 1843 a Parisian daguerreotypist, Marc Antoine Gaudin, is said to have been the first to use the phrase, 'Now watch for the dicky-bird'. Perhaps this was an early crude attempt to lessen the ordeal of the sitting and, in fact, to adopt a psychological approach.

Charles Lutwidge Dodgson, better known as Lewis Carroll, the author of *Alice In Wonderland,* and also the leading photographer of children of his time, was probably the first to give as much attention to the child as to the camera. An eccentric, who admitted to being fond of children, 'except boys', he employed psychological methods, remarkable in his day, to win over his child camera subjects. Children loved to visit him. Such occasions were always full of surprises. He always had on hand a variety of games, toys and puzzles which he sometimes produced from a famous black bag. And, of course, there were stories and nonsense rhymes to amuse the children and to help promote a favourable atmosphere for the photography to follow.

Alice Liddell, the original 'Alice in Wonderland' was one of his favourite sitters. His best stories were made up for her entertainment, either in his rooms or on picnic boating trips up the Isis, and she it was who persuaded him to write them down. Often, as he busied himself preparing his camera he kept her enthralled with 'the most lovely nonsense imaginable'.

Carroll also departed from the conventions of the times by preferring children to be 'natural – sometimes with ruffled hair'. He sometimes photographed them in costume, although he declared that he did not like them 'dressed up'.

He was able to project himself into the child's world and to think like a child. His ability to gain acceptance from a child – on a train, on the beach or in the street – would certainly be an asset to modern child photographers. Would his stories and tricks have won over today's child? I think so. But to judge by one of his verses, even *he* sometimes experienced difficulties in handling his small models:

> *From the eldest, Grinny Haha,*
> *Who, throughout her time of taking,*
> *Shook with sudden ceaseless laughter,*
> *With a silent fit of laughter,*

To the youngest, Dinny Wawa,
Shook with sudden ceaseless weeping:
And the pictures failed completely.

Many years later, Marcus Adams, kindly and patient, is said to have first used the expression that child photography was ten per cent technique and ninety per cent psychology. His photography was almost exclusively of children. He employed such devices as a camera disguised as a doll's house with the lens peeping through a window, and he took time to get to know the children before he even touched his camera. In the Royal Photographic Society's Pictorial Annual of 1926, Mr. F. C. Tilney, F.R.P.S., wrote that Marcus Adams had a great reputation as a photographer of children. 'Although every expression of infantile character is recorded by him, he has, perhaps, a favourite aspect for his little girls. It is demureness. Given a pretty child in an unusual or antique dress, standing nicely, or being good because she knows perfectly well what is expected of her, our captivation is a foregone conclusion. . . . Few have so happily given the touch of quaintness that attaches to past modes as has Marcus Adams.'

His work had a great influence on studio photography of children for a considerable time but how far off those demure children of the twenties seem now, almost as unfamiliar to us as the stoic young Victorians. Children brought up in today's permissive society are seldom demure and most photographers acknowledge the necessity to use psychology in handling them. Mr. Joseph A. Sneider of New York, well-known specialist in child photography, is also a fully qualified psychologist, having served as a psychological consultant for problem children in New York for ten years. A far cry, this, from the early tentative attempts to coax or cajole children into cooperation, mostly with a view to inducing them to keep still. Study of child psychology in some depth is now considered by some to be necessary in coping successfully with children exposed to the strains and tensions of the second half of the twentieth century.

Technical improvement

Child photography was made technically easier by a series of inventions. and improvements. In 1871 Richard Leach Maddox's introduction of the dry plate, using gelatine to hold the silver bromide, relieved photographers of the tedious task of preparing plates prior to the sitting, and processing

them immediately afterwards. The invention of the dynamo made electric lighting possible, and many studios fitted gas or electric lighting, allowing what seemed a great novelty at the time – photography after dark. At last sun pictures did not require the sun. It became fashionable to have the children's photographs taken by artificial light, the exposure being something like six to seven seconds for cabinet portraits.

Artificial lighting provided photographers with another control in addition to backgrounds and retouching, with which to influence the character of their portraits. Unfortunately it was not always used with skill and results often fell short of those achieved with daylight.

'Special background effects for children' were sometimes advertised and whereas adults were offered settings suggesting opulence, children were posed on imitation rocks or rustic bridges. They were liable to be dressed as cupid or have their heads thrust through holes in giant cardboard birthday cards. Even the serious amateurs, not concerned with producing quantities of portraits as a means of livelihood, descended to work of 'treacly' sentiment, and lacking in taste. Victorian photographers had a passion for dressing up children to represent characters from the Bible or the classics in contrived 'illustration-pictures'. A few of these emerged showing good taste, the most successful being those in which there was no attempt to imitate painting.

Improvements to the speed, quality and colour range of sensitized materials and, in 1888, the introduction of the first Kodak rollfilm camera, helped to free the photographer from the limitations of the early studios. 'You press the button – we do the rest' was the Eastman advertising slogan and the hobby was opened up to a new public who could take family snapshots and hand them over the counter to be processed. Some of the mystique vanished at this moment and photographers were no longer regarded as cranks.

The miniature camera, at first regarded as a toy by professionals, eventually enticed them out into the world to photograph children in their natural surroundings. Owing to the comparatively short focal length of miniature camera lenses, they had a much greater depth of field than equivalent lenses in larger cameras. Thus they were suitable for many subjects, but none more than children. Not only did they make it easier for the photographer to keep the children in focus while at play, he could also remain unobserved. And although the changing style of photography demanded new and more precise processing techniques, with care negatives were produced

which could be enlarged quite considerably without showing objectionable grain.

Colour and automatic cameras

Whether colour has added anything in an aesthetic sense to photography as an art form is debatable. Often it merely adds prettiness, and the chiaroscuro of a black and white print with well-arranged lines and masses and tones often has more impact. But it must be admitted that an appealing child picture is even more appealing in colour. Still regarded as a comparative innovation, it may come as a surprise to many to learn that colour photography was shown to be possible as early as 1861. In that year James Clerk Maxwell photographed a tartan ribbon through blue, green and red filters, making three plates. These he projected through the same filters, simultaneously through three lanterns, superimposing the images on one screen. His astonished audience saw the first colour picture by a photographic process. The achievement was particularly remarkable when one considers the limited colour sensitivity of materials in those days.

Since then, of course, many workers have made contributions to the development of colour photography. The additive process was later developed using one transparency, the image being composed of a mosaic of multicoloured elements. The 'subtractive' method was introduced in 1905. Screen colours were now formed as a result of individual images subtracting colour from light transmitted through them. Three emulsion layers were filtered and sensitized in such a way that three images were formed through blue, green and red filters. And today we have a bewildering range of colour films in various types and sizes. We can have colour slides or colour prints. And indeed, the unskilled photographer can produce a colour print from the back of his camera in less than a minute, thanks to the invention of the Polaroid Land camera by Dr. Edwin H. Land. For the present-day photographer of children, emphasis has swung right away from the earlier preoccupation with technical considerations. Children can be photographed everywhere and success depends more on the perceptiveness of our eyes than on technical skill. If we so desire, we can now use a camera which almost thinks for us and automatically adjusts to the correct exposure. Even so in different hands the camera produces very different results.

The photographer who is master of his craft puts his own individual

stamp on his work. His choice of angle and lighting and moment, even what he does *not* take, are like a signature on his pictures.

Most professionals regard automatic cameras and 'instant photography' with some suspicion. And certainly there are some drawbacks. Retouching and printing controls are not possible when the processing is done in the camera. And the image still lacks permanence. The 'magic eye' cannot make artistic assessments of the subject. In contre-jour effects, for instance, it cannot decide whether to expose for the figure or the background, whether to give you a detailed portrait or a pictorial silhouette. But the world-famous photographer Edward Steichen has turned to the automatic camera at the age of 87. He regards it as the greatest invention since the daguerreotype. He has always resented the mechanical demands of his camera. After all, he argues, the technical aspects of photography are purely mechanical.

What of the future? There cannot be electronic aids to perception and gaining a child's confidence. May we hope for much simpler advances, such as a really silent shutter which will not attract the child's attention? And colour images that, even exposed to sunlight, will last at least until the child becomes an adult?

2 The Studio

A studio is merely a room with a suitable wall for a background and some controlled lighting, whether it be daylight, tungsten or flash. It could be almost any room – the lounge, an attic, or a room specially made for the purpose. But if you intend to photograph children you must create in it a favourable atmosphere.

Play studios

Every room has a character, an atmosphere of its own. You can probably recall a room in which you had an uneasy feeling, perhaps an old room in an old house, with an almost sinister atmosphere. What, on the other hand, could be more inviting than a farmhouse kitchen with firelight dancing on polished brass and the smell of newly baked bread? Yet these are both just rooms, with walls and a floor and a ceiling, filled with items of furniture. Some people are more sensitive to atmosphere than others and all children seem to be particularly so. Your play studio must be a room that children find exciting and do not want to leave.

How do you create an atmosphere? Colour, shapes, lights and associations play their part. Try to imagine the things that would put you on your guard if you were a child, and avoid these. Keep the room fairly small and see that it is well lighted apart from the photographic lights. Would you like to sit in a pool of light looking into dark corners? The walls should be light in colour; in fact if you are shooting in colour it is safer to have them white to avoid colour reflections.

I always have shelves overflowing with toys. What child is reluctant to enter a toy-shop? Sometimes I have animated novelties, such as a Punch and Judy show with electrically operated puppets, or cut-out animals and circus posters on the walls. These things are changed from time to time, but the atmosphere is always bright and gay. The professional photographer must create the right atmosphere all the way, from the display and the reception-room to the waiting-room, in which he leaves a few toys and books. A tank of tropical fish helps considerably to break the ice before the sitting begins. And, of course, your own manner, the way you behave and speak, have a great bearing on creating a pleasant atmosphere for child photography.

Home studios

A photographic session in the home requires some preparation and a good deal of understanding on the part of the 'little woman' whose province is

about to be invaded and disrupted. The need to rig up a sheet or ciné screen as a more suitable background than the room décor, to set up lighting equipment, and shift furniture, often leads to a desire for a more permanent arrangement, perhaps in a spare room or a garden shed. In such conditions you can have walls suitable for backgrounds and lighting equipment which does not have to be dismantled and stowed away after every session.

Even a photographer who prefers to photograph children outdoors may sometimes wish for a studio of some kind. Let us say, for instance, that you are observing an adventure playground with your camera out of sight. Children are having a great time, climbing trees, swinging on ropes, rolling in barrels, endless picture possibilities. In a quiet corner you notice two small boys, one coloured the other rather grubby, absorbed in the solemn task of building a boat from pieces of waste wood. Their expressions of deep concentration make a picture and they are much too preoccupied to notice your camera. But other children have seen it and they come crowding round you, cutting off the light that was reflected off the ground on to the features of the two boat-builders. Cheeky, grinning faces now fill your viewfinder.

The picture, which you had already imagined hanging at the 'Royal' or printed in *Life*, is lost for ever. On such occasions, the temptation is to set up the picture in the studio. Take two small grubby boys. Give them a half-finished boat, a hammer and some nails. Wait for them to get on with the job. But this time, the lighting is right, the background is right and there are no grinning faces to get in the way. You might still get a picture.

On a similar occasion, I noticed a small boy examining his catch of sticklebacks in a jam-jar. Poor light and a brick wall background, too near to the subject to be put out of focus, precluded the possibility of a 'salon' picture.

When the picture was set up later in my studio, we added the boy's pal, Whiskers, a tabby cat, who displayed some interest in the fish. Unfortunately, the first time he dipped his paw into the jar rather in the manner of a famous cat in a television commercial for cat-meat, the fish had managed to render themselves invisible to the camera by swimming to the side of the jar into the distortion caused by the curvature of the glass. But Whiskers, having got his paw wet to no purpose, was reluctant to repeat his performance. I eventually induced him to do so by placing a small piece of fish

paste just inside the neck of the jar. The cat's antics amused the boy, who momentarily forgot the camera and the resulting picture has been widely published and exhibited all over the world.

Studio dimensions

Probably the ideal length for a home studio primarily intended for children would be about twelve feet. This would allow you to place the child about four or five feet from the background. A child two feet high, taken full length on $2\frac{1}{4}$ in. square format, allowing a little space above and below the subject, would require the camera to be about four feet from the child, thus allowing about three feet for you to move behind the camera. The width of the studio should be about ten feet to allow you to position your light stands. This size of room would allow you to photograph children up to school age full length by placing your camera close to the back wall. Adults could be photographed close-up or three-quarter length. If the studio is to be principally for photographing children it should not be much larger than this for psychological reasons, as children tend to react more favourably in more intimate surroundings. Although I have a much larger studio in which I can photograph quite large theatrical groups and so on, I have found it advisable to have a separate, smaller studio for the little folk. To appreciate this, one has to try to imagine what it is like to be put in the middle of a large room in a pool of light with large items of equipment lurking in the shadows, when you are only two feet nothing.

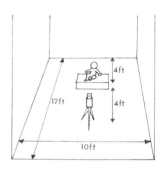

To confine the child's movements to within a few feet a 'posing bench' (for want of a better description) is required, although posing in the accepted sense is not intended. It is worth constructing a box about eighteen inches high and with a surface area of about two feet by four feet for this purpose. The camera should be on a lightweight stand with a pan-tilt head and provision for rapid raising and lowering of the shooting level. Thus, with the camera set up and focused and the child's movements confined to a relatively small area, you are free to wander with a long release in your hand, and devote your full attention to the child. If you use a pneumatic release perhaps ten feet in length you can keep the bulb in your pocket or even leave it on the floor and expose by stepping on the bulb.

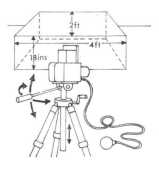

Although lighting is discussed in greater detail elsewhere, a few points should be mentioned here in connection with studios. I would consider two

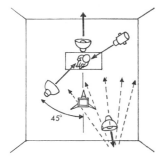

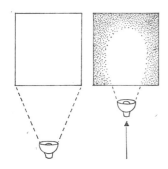

photofloods the minimum workable number, one to be used as the principal light source at a 45° angle, the second to be reflected off the white wall behind the camera to serve as a fill-in. Further improvements could be introduced, such as another photoflood in a reflector placed on the floor, directed on to the background, which should also be white or light-toned. This light could be moved closer to the background, or closer to the child, according to the effect required. At about one foot from the background it would produce a pool of light merging into shadows at the corners of the picture. On the other hand, if it is moved to about four feet from the background this is likely to be recorded as an almost over-all white. The introduction of a baby-spot as a fourth light calls for some care in handling. Ideally, it should be on a boom so that you can position it with precision over and behind the child, where it picks up highlights in the hair without straying on to the forehead or nose.

With this basic studio set-up, most kinds of child picture are possible. The important technical factors are covered and the main problem must now be the handling of the child. There is scope for much ingenuity in arousing the child's interest and in creating props to allow flexible use of lights and camera position. It is worth looking at some of the methods of leading professionals for ideas.

Facilities

Mr. Edvard Welinder of Stockholm was famous for high key portraits of children in the clean simple style which has come to epitomize the Swedish approach. He believed that child photography not only needed a special knack, but special equipment also. He invented an ingenious 'lazy tongs' stand for his Mentor 9 × 12 cm. reflex and his Swedish Hela camera which gave four 9 × 12 cm. negatives on 18 × 24 cm. and had an electronic exposure device and automatic film-feed. This stand gave him much freedom for camera movement and he also had a specially designed set of posing furniture; blocks of various sizes, could be used separately or arranged as a staircase, small platforms, upholstered benches adjustable for height, and a special device for posing young babies. This consisted of a seat for the baby and a small stool for his mother, both mounted on a small platform on castors allowing it to be quickly moved to different angles.

His lighting, of the simple frontal type was not quite as simple as it

appeared. It consisted of a trough with three 1,000 watt incandescent lamps and two mercury tubes, and a 500 watt light controlled by a sliding resistance, directed on to the plain white background. He found this light adequate without a frontal fill-in but bounced a 1,000 watt light in a reflector off the ceiling on the shadow side.

'From the psychological point of view,' he said, 'a truly satisfactory sitting commences with the entrance of the small subject into the studio. If a studio deals exclusively with children, a special room should be arranged for them, with suitable furniture and appropriate illustrations on the walls. I have a play-pen with cushions in which a mother can place the smallest baby with safety, a small modern car and large blocks, all of which serve to occupy youngsters while they are waiting and help to dispel their almost inexhaustible energy.

'Let us take first a single child or baby. After I have become acquainted in the reception room and made my preparations in the camera room, the child comes in. If a small baby, it is brought in in the mother's or nurse's arms. If it can walk or toddle it is led in, preferably by my hand. A few tunes from a rubber kitten in my pocket or the showing of a cute little deer about which I talk and tell stories, will usually catch a child's interest at once.

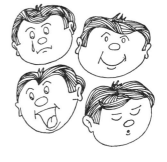

'I try to get the smiles all parents want from their hopefuls, because I know that without a smiling picture they will not be satisfied. I usually draw a smile from very young children by making sounds or whistling. Older ones will respond to playing peek-a-boo or squeaking a toy. For the more reserved youngsters it may be necessary to resort to an animal glove puppet. But to maintain the illusion it is necessary to talk constantly to the animal. All the time I am working I am watching for other expressions – serious, meditating, questioning and the like. One thing which always applies is that you yourself must always be calm, natural, friendly, and patient, keeping up a stream of patter to distract the child from what is going on. Talk to them naturally about something within their sphere of interest. Follow up every clue and draw on your imagination. The photographer of children has to be a psychologist.'

While most child photographers today believe that a brief exposure is necessary to catch youngsters, Edvard Welinder believed in slower speeds. He invariably used $\frac{1}{20}$–$\frac{1}{25}$ sec. at $f4.5$ to $f6.3$. 'To secure the expression properly', he argued, 'the features must be at rest for the length of the ex-

posure. It is that resting moment in an expression that is the most beautiful, the calmest and the most characteristic of the subject.'

When a qualified psychologist takes up child photography it can be assumed that he has a tip or two for the rest of us engaged in this difficult but delightful task, whether we be professional or amateur, advanced or beginner. Therefore when Joseph A. Sneider of New York sent me a delightful picture of a child holding his toes, I was interested to read his accompanying notes. 'Very frequently', he wrote, 'mothers call me up and warn me ahead of time that while they want me to photograph their child I will never be able to keep him long enough in one spot. I tell them that it is my job and to cease worrying. But this youngster could crawl faster than I could run. By putting bits of cracker between his toes, he very deftly managed to get the crumbs to his mouth. And as he was busily engaged in extricating these tit-bits I waved one whole cooky in front of him and he looked up exultantly. In the past I have used the technique of putting Scotch tape on youngsters' feet but the way to a man's heart is obviously still through his stomach.'

Environment for a child

It is generally assumed that a visit to a studio is bound to be a terrifying experience for a child. Parents often subscribe to this belief and, by word and attitude, communicate their apprehensions to children who would otherwise enjoy the excitement of a new experience. Adults are themselves afraid of the camera and the studio has been compared to the dentist's surgery since the days of head-clamps and long exposures. It is no longer necessary to bully children to keep them still and today the studio, if properly designed, will usually excite their interest and curiosity. The children, too, are changing under our noses. Most of us expect them to react as we did when we were young, but they have grown up in a different world and have shed many of our inhibitions. Today's children are seldom afraid. Wilful, sometimes. Demanding, usually. Often ready to stage a demonstration to get their own way. But, afraid? Hardly ever.

As any mother of healthy youngsters knows only too well, boredom is the biggest problem with children today. Keeping them amused, especially during school holidays when older brothers and sisters are home, is a task beyond many parents. And this situation has brought the studio back into

its own for child photography. For, while home surroundings are too familiar to the child, the very strangeness of the studio, usually considered to be a disadvantage, is in fact, its greatest asset. Children enter it cautiously, but if we use our ingenuity to make it an exciting place, we shall hold their interest long enough to get our pictures.

If children are sensitive to their mother's innate fears of the camera, they are also likely to be influenced by the photographer's feelings towards them. The famous Swedish photographer, Mrs. Ann-Marie Gripman, whose warmth of personality coaxed from children a variety of delightful responses, once told me, 'It is not sufficient to like children, you must love them devotedly.'

'As you know,' she continued, 'children do not act as grown-ups. If they do not like you they show it, openly and honestly. In other words they cannot pretend. You may object that in many cases my pictures of children, crying, with pet-lips or showing suspicion, clearly indicate that they do not like me, but that is how I wanted the pictures, perhaps to protest against all the "dollish" pictures I have seen. If a mother tells me that her child must laugh in the picture I tell her that "those laughing pictures are good, of course, but it is much nicer to have a sullen picture if it is natural. Look at my child portraits. You certainly agree with me that the serious ones are often the nicest ones". When I tell a mother that her child is beautiful, but perhaps more so when he is sullen, and tell her that I simply have to have a grumpy picture, then she slowly begins to agree that there is something in it, that the child should be himself, even if he is grumpy.'

'Nowadays it often happens that the mothers want a picture where the child is yawning, crying or slobbering, perhaps because they hope the child might be one of my exhibition pictures.'

Mrs. Ann-Marie Gripman said that when she was photographing children she tried to make herself as old as the child. Of course she was exaggerating. She could not become six months old again, no matter how much she might want to, but there must always be the desire to understand children. She remembers with pride the occasion when a little girl of four or five years looked up at her saying, 'What are you going to be when you grow up?' She considers the purpose of her child pictures to be to make the mothers feel, even when the children are grown up and away from home, how warm, downy and perhaps also how wet they were.

She, like most successful photographers of children, has fun with them in

the studio. And they also have fun. It has always given her satisfaction to see how unwilling children were to leave the studio. Almost every day there were tears but it was almost always because the photography was such fun and the toys so difficult to leave. 'But most lovely of all is perhaps to feel little arms around your neck. After all I am a woman.'

Homes and gardens as studios

Mr. Desmond Groves, the internationally known portrait photographer, says that he never goes anywhere without two objects – a white sheet and a teddy bear. In a sense these simple things symbolize his approach to photography, particularly of children. The sheet, white on one side, and silver on the other, was given to him by a Swedish photographer and indicates a fondness for *contre jour* effects. Held by an assistant reflecting light into the shadows, the white side is usually sufficient, the silver side used when more reflected light is required.

The teddy-bear is used so much by Mr. Groves to amuse children, that he feels he ought to have a miniature bear in the corner of all his pictures as a signature, rather in the manner of the famous Yorkshire carver who still carves a tiny mouse on all his work.

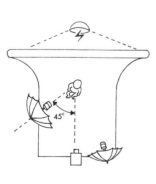

Desmond Groves is a keen advocate of the umbrella-flash technique. In the studio he uses two umbrella lights – a small white one in proximity to the camera, and a larger silver one to give a slightly crisper effect, mostly at a 45° angle, keeping the fill on the same side of the camera as his main light. For studio backgrounds he often uses a roll of seamless white paper, pulled forward to cover the floor, eliminating any horizon line. Behind this he places his third and last flashhead, directed forward to illuminate the background from behind. In this way the floor behind the sitter is left uncluttered. Sometimes sprays of leaves behind the paper produce shadow effects. The camera used is a single lens reflex taking 120 film and Mr. Groves operates it with a long pneumatic release enabling him to be beside his subject. An assistant focuses and winds on the camera.

Mr. Groves admits that he is more concerned with the psychological aspects of child photography than with the technical side. He abhors the questions people ask at photographic meetings, regarding developers etc. As for exposure, he declares that it is always the same – $1/15$ sec. at $f8$ – with colour or black and white. He prefers to adjust the intensity of his lighting

rather than change speed and aperture. Working with ultra fast electronic flash in the studio, the duration of the flash will become the effective exposure time.

When working in beautiful houses which provide the settings for many of his child subjects, a slower speed allows the atmosphere of the home to come through. Flames of a fire beside which a child is sitting are registered due to the relatively long exposure, without being overpowered by the flash. A child beside a window is backlit by daylight, the shadows filled in with reflected flash or reflector, but the light from a candelabra is allowed to show. Or perhaps the child is lit by the bounced flash while daylight falls naturally on a bowl of flowers. Out-of-doors, in beautiful garden settings, he usually finds soft daylight and a white reflector sufficient. He dislikes the fill-in flash in these circumstances because of its artificial effect.

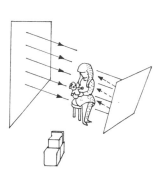

Desmond Groves started his meteoric photographic career in his Somerset home of Yeovil on leaving school. He studied in London with well-known photographers. A spell in advertising, theatrical and fashion photography gave him valuable experience. Later he returned to his first love – portrait photography, when he joined a famous court photographers as studio manager.

In 1954 he opened his own studio in Wilmslow, Cheshire, and soon from this small north-west town earned a world-wide reputation.

Children's studio in a store

In 1969, he was invited by Harrods, the London store, to open a portrait studio. The result is probably the finest such studio in Europe. There are separate magnificently equipped studios, each with appropriate fittings, and one of the features of the children's studio is a gallery with one-way window through which parents can observe the sitter without being seen by the children.

It is relatively easy to describe a photographer's technical approach. It is much more difficult to define his technique of reaching rapport with a child. Probably only a professional of wide experience in this branch of photography will really understand what is involved. One has to be extremely sensitive and to constantly adjust one's approach. Desmond Groves says that each sitting is a performance, and, like an entertainer, feels deflated at the end. His sittings with children usually take no more than ten minutes.

When he goes for smiles, these are not because they are more successful than serious expressions, but because the parents leave saying, 'Wasn't he marvellous with the children?' Psychologically they are sold before they see the results of the sitting. I have had the privilege of watching him work. First there were three little girls waiting apprehensively. They were aged about eight or nine. 'Come on, sausages', he said briskly, 'what are you waiting there for?' His manner is not cautious or coaxing. He imposes his strong personality on his young subjects. He sweeps them along with his confidence and they have been manoeuvred into various escapades and the shutter clicks repeatedly before they have time to become self-conscious.

'What letter does your name begin with?' he asks one of the girls. 'G? Let's see. You must be George. And yours with K. You must be Keith.' In no time their shyness falls away and they positively shout their correct names at him.

'Let's play a game,' he says, 'You say "sausage" to everything I say to you. What's your name?'

'Sausage', shout the girls.

'Oh, is it? And what do you look like?'

'Sausage!'

– and so it continues as the pictures build up. By this time the ice is completely broken, the girls are reduced to giggles and have been deftly guided into various groupings without being aware of it. The flash has been fired frequently. Mr. Groves using the long release and not glancing at the camera.

A three-year-old was next, brought into the studio by her father who promptly retreated to the viewing gallery. The little girl hardly noticed that she was on her own because of Mr. Groves's sense of fun, his jokes and personality. A child can hardly help laughing with a man who has a twinkle in his eye, can balance a teddy-bear on his head and produce squeaks at will from various parts of your anatomy. The flashes fire at precisely the right moments, anticipating and catching telling expressions with a skill and mastery which only comes with great experience.

At one time Desmond Groves concentrated on colour photography to such an extent that eighty-five per cent of his work was in colour. But latterly he has been taking a fresh look at black and white. He now feels this will survive, and indeed that it is more effective for some subjects.

Mr. Groves's attitude to his work has changed over the years. Whereas

earlier he built up complex lighting effects he now prefers simplicity. Similarly, in place of a dynamism which he earlier strove to portray, he now seeks a calmer, more serene atmosphere in his pictures. However, a man of Mr. Groves's exceptional talents is never satisfied, he will continue the eternal search for perfection in his portraits.

A fundamental principle in lighting for child portraits is to keep the lighting as simple as possible. But not, let me hasten to add, as simple as the flash-on-camera technique which flattens and distorts the features. Even that type of lighting can be improved by bouncing the flash off the ceiling, but I find that this method does not get enough light into the eyes, which are, after all, probably the most important feature in the picture of a child. If you are using bulb flash I think it is better to use the flash on the camera, well-diffused, as a fill-in light, with a second flash held above and to the side of the camera to act as the main, or key light. This gives good modelling and shadow detail and also catchlights which add sparkle to the eyes.

With tungsten lighting the main light can be placed at a point on an arc, five or six feet from the child and at a height which will throw a small shadow under the nose. I like to place this light so that the nose shadow falls towards, that is, on the same side of the face as, the camera. In profile shots, the main light can be placed slightly behind the subject – outlining the features, and allowing a triangular patch of light to fall on the nearer cheek. A darker background is essential for this technique to contrast with the highlight outline. For a full-face shot the light is moved along the arc to a point near the camera or even above the camera.

The ideal place for a fill-in light whose purpose is merely to reduce shadow density would theoretically, be exactly where the camera lens is. This would be very inconvenient. Almost the same effect can be obtained if this light is placed as near to the camera height and angle as possible but some way behind it. You must remember however, not to cut off this light yourself by standing in the beam while you are playing with the child. In child photography a strong dramatic lighting is seldom suitable, but the fill-in should be placed at least twice as far back as the main light and also diffused. When I have been called upon to judge club competitions the biggest single fault which has come up time after time has been that the fill light was too near.

We now have an adequate lighting set up but the hair will probably be rendered too dark and be lacking in detail. So a third light is often required above and behind the kiddie. It can be on a stand high on the shadow side (i.e. the side of the subject opposite the key light), mounted on the wall above the background or, best of all, on a boom, so that quick and precise adjustments can be made to pick up highlights in the hair. This light should also have a shade or snoot to prevent extraneous light reaching the lens and

causing flare. If the subject is a child who is a little 'thin on top' this light should be taken well back or 'killed' altogether.

A further improvement to this lighting might be made by introducing a fourth light on the floor behind the child to light the background. This is almost essential if you are shooting in colour, otherwise the colour of the background tends to be unpredictable.

Electronic flash

For many years I used the four lamp set-up described above with tungsten lighting – sometimes substituting spotlights for flood. I was satisfied with an exposure of 1/30 sec. at *f*5.6, although this called for careful timing for the moment of exposure and a watchful eye to ensure that the child did not wander out of the field of focus. But colour photography presented problems of colour temperature to which the consistent quality of electronic flash was the obvious answer. I still held back, however, fearing any psychological effects on the child due to the bright flashes. When I finally switched over I found these fears to be groundless. Babies seem hardly aware of the flash and toddlers are often highly amused by it. And I now enjoy the luxury of shooting at 1/600 sec. at *f*16 with H.P.4 and *f*8 with an 80 ASA colour film – a far cry from the half-second (and longer) exposures necessary when I started photographing children in the studio over thirty years ago. But the experience of photographing thousands of children at those slow speeds, which meant that they had to be almost hypnotized, developed a sense of timing and anticipation invaluable to me today.

I have a flash outfit of moderate power, which I find first-rate for children. The power is divided among four separate flash heads as follows:

Main light	100 joules
Back light	100 joules
Fill-in	50 joules
Background light	50 joules

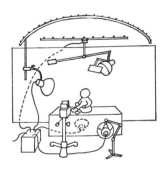

The duration of the flash (approximately 1/600 sec.) is certainly fast enough to 'freeze' a ball in mid-air or the gyrations of the liveliest of children.

An aperture setting of *f*16 gives so much depth of field that differential focusing is very difficult. So the background which is always likely to be rendered sharp has to be unobtrusive and with not too much contrast.

Plain white, or perhaps a pale blue with a suggestion of white clouds, are probably the most effective.

It is most important, and especially when using colour film, to reduce the variable factors as much as possible. The introduction of electronic flash lighting ensures a constant colour light (approximating day-light) a constant intensity of light and a constant speed. But if the flash heads are mounted on stands in the conventional studio manner, there is bound to be some variation in the amount of light reaching the subject unless the distance between the child and the light is frequently checked. Unfortunately children do not allow you to fiddle with tape measures and gadgets and in any case the entire studio set-up should be so arranged that you can devote most of your attention to the child.

A great advantage of the electronic flash studio set-up to be described here is that it is a simple matter to switch from black and white film to colour in a moment. The lighting is equally suitable for daylight transparency material and neg-pos colour film. I have merely to switch to my second camera which is loaded with a negative colour material and set the aperture at $f8$ (instead of $f16$ for black and white.) The constant distance between the main light and the child is even more important when shooting in colour, but the fill-in light should be moved in slightly to reduce the shadows.

Making a lighting rail

My solution to this problem was to fit a semi-circular lighting rail or track to the studio ceiling. For this I used ordinary curtain track obtained from a hardware store. Using the brackets supplied with the track I screwed it along an arc described on the ceiling, with a point immediately above the spot in the studio to be occupied by my child sitters, as its centre. The track can be five, six, seven feet from this centre point according to the size of the room and the power of the lighting and so on.

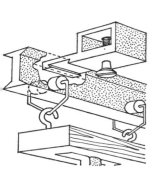

Next I constructed a small 'carriage' which simply consisted of a piece of wood about four inches by two inches by one inch. On the top of the wood I screwed two cup-hooks about one inch from each end. A curtain pulley was hooked onto each of these. A length of conduit tubing was attached to the underside of the piece of wood by means of a bracket. The length of this tubing must depend on the height of the ceiling. When the pulleys are

slipped onto the end of the semi-circular track, with the wooden 'carriage' suspended beneath, the tubing attached to the underside of the wood should hang down to about four feet from the ground.

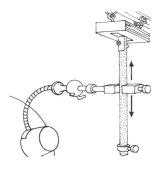

The flash head in its reflector should be attached to the tubing in such a way that it can be readily raised or lowered along its length. In the case of the Langham heads (or Ultralights) I use a piece of flexible tubing is attached to the reflector. This tubing will screw onto a camera bush and will therefore attach to the small fitting designed to clamp a camera onto the edge of a table.

It is a simple matter to attach this clamp to the hanging conduit tube so that now the flash head can easily be swung round and will remain equidistant from the spot to be occupied by the child at any point on the arc. In addition, the lamp can easily be raised and lowered by simply loosening a wing-nut on the clamp, moving to the required height and re-tightening the nut. Curtain track is strong enough to support such a contrivance with a lightweight flash head in an aluminium reflector. Heavier equipment would, of course, require more substantial track.

Using the lighting rail

The table, box or platform on which the child sits is positioned so that its centre coincides with the centre point of the arc and you must endeavour to keep him in the vicinity of that spot. If he is sitting for a close-up shot, perhaps at a small table with a book, this task is relatively simple. If he is standing and having a game with a ball it is more difficult. But if he moved a few inches this way or that it is not likely to make much difference.

Using the advantage of the high speed of the flash I frequently take pictures of 'small fry' in a swing. I hang the swing on hooks in the ceiling so positioned that the highest backward movement of the swing coincides with the central point of the lighting. I take my picture when the swing reaches that point and the trick is, by means of play, to get the best expression from the child at the precise moment when the swing has reached the best lighting spot, which is also the point on which the camera has been pre-focused. It is no additional hardship to remain aware of the child's position in relation to the central point, because this is necessary in any case to ensure that the child is within the field of view. It is not a good idea to check your camera too often as this is distracting and in some cases disturbing to the child. Pre-

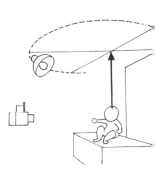

occupation with equipment will lose the vital contact with him that you need.

Backlight rail

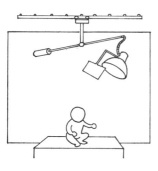

The backlight can also be suspended from the ceiling by a similar method, using a small wooden 'carriage' fitted with pulleys, in this case running on a straight length of sliding door track which is more robust and capable of carrying a heavier weight. The track runs parallel to the background and about two feet away from it. In this case the hanging tube has a small counter-balanced boom attached to it and the flash head is mounted on this. Again, this device makes it possible to place this light in any desired position speedily and with ease. On the floor behind the platform is a light, directed onto the background. This light and the fill-in, diffused and placed well back near to the camera angle, require little adjustment once their most effective placings have been established by test. Model lights of low voltage positioned in the centres of the flash tubes provide an accurate check of the lighting balance, but it must be remembered that the normal room light, probably hanging from the centre of the ceiling, upsets the visual balance of the model lighting and should be switched off in an accurate assessment of the lighting balance is required. Since this light has no effect on the finished picture there is no reason for leaving it on except that in my case I leave it on because I want the studio to seem as much like an ordinary room as possible. Children are sensitive to such apparent trivialities and could be put off by directional lights in reflectors, reminiscent of doctor's

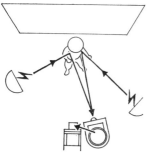

and dentist's surgeries. I find that if the brightest light is in the normally expected place children are less likely to notice the photographic lights. In practice, however, one quickly gets used to rapid changes of lighting without close study of the effect, and the model lights could almost be dispensed with.

Exposure reading should be done with a flash meter or, as I prefer, by a series of test exposures. Once the exposure-development ratio for the film is established it is seldom necessary to make adjustments in these controlled conditions. The flexibility of this lighting set-up and the ease and speed with which it can be changed, make it ideal for child photography in black and white or colour. With experience, setting the lights becomes almost instinctive, leaving you free to devote most of your attention to the vastly more

difficult and more interesting task of handling the child. Most of my pictures in this book were taken with this lighting arrangement, exactly as described. I must leave it to the reader to decide whether these methods have proved successful.

Umbrella light

When I was a child, in the early twenties, I used to like having my photograph taken by the local professional in our small town. I was petrified by the actual experience, especially when he trundled up his huge juggernaut of a camera with its large staring eye. But this moment of terror was worth enduring because on the days when I was to be photographed I got off school early, before the light faded.

Dressed in my best sailor-suit with a straw hat I was a subject for the derision of my class-mates. But their jeering turned to envy when I was called for at three o'clock and hurried off to the studio. Sometimes the photographer, a flamboyant figure sporting a cravat and wearing a smock in a self-conscious effort to appear 'artistic', would announce that the light was not good enough. This was music to my ears because it meant another hour stolen from school on the following day.

The roof of the studio was all glass like a greenhouse, with a complicated system of roller-blinds enabling the photographer to control the light, when there was enough of it! Even on a good day the exposure would be several seconds because he used large plates, probably whole plate or even larger, and, being a better-than-average photographer, attempted good lighting by restricting the amount reaching the subject, unlike most of his professional colleagues of the day who flooded the studio with as much light as possible in order to reduce the exposure. In spite of my apprehension, when I was instructed to 'keep quite still and smile – *now*', I obeyed. We were stoics in those days.

One day this photographer got 'with it' and installed artificial lighting to supplement the daylight. He still felt daylight to be best and so his artificial light was made to simulate the light coming through his glass roof. In order to retain the daylight quality he bounced his new light off a huge white umbrella. When next I was taken to the studio for my annual picture I thought the umbrella had been installed because the rain was coming through the glass-roof. But the photographer knew that by using this method

he got the nearest thing possible to the effect of daylight. I cannot remember what kind of artificial light he had. Probably a carbon arc – or it might even have been gas. But by directing the light on to the umbrella, which scattered it, so that it bounced off the walls of the studio, he achieved the soft 'round' lighting considered ideal for portraiture.

Forty-five years later the umbrella light is back in various forms. There are large ones for use in studios and small portable models for the amateur. Today, of course, they are used mostly in conjunction with electronic flash, although they can be applied to photoflood lighting. Ironically, portrait photography having gone through many cults, including the diffused out-of-focus look and the multi-light glamour set-up influenced by Hollywood in the thirties, is now making a reappraisal of daylight. The speed of modern cameras and materials has enabled photographers to make more use of 'available' light, be it daylight or normal room lighting or a mixture of both. Fashion photographers have re-discovered the quality of daylight and its facility for rendering soft gradations and textures. The most convenient light away from the studio, but undoubtedly the worst, has been the flash-on-camera arrangement with its inevitable outline shadow behind the subject and distortion of noses, ears and so on. The improvement made by taking the flash off the camera and directing it on to walls or ceiling is well known. But there is an element of hit-or-miss about this technique, which varies according to the nearness and colour of the reflecting surfaces. I also find that there is the added disadvantage of 'dull' eyes where there is no frontal light. I do not suggest that the umbrella light, or para-flash, is suitable for all occasions. Obviously it is unsuitable when a photographer wishes to remain unobtrusive. You are hardly likely to remain unnoticed setting up a white umbrella on a stand. But for amateur at-home sessions, or taking party groups it has much to commend it.

For the professional, too, the para-flash provides virtually a portable studio lighting for portraiture. As will be seen in the accompanying examples, pictures taken with a single flash bounced off the umbrella compare reasonably with photographs of the same subject taken with a four head flash set-up in the studio. This method is excellent for colour. In a room with light-coloured walls, detail is retained into the shadows remarkably well without a fill-in.

The para-flash black and white picture is generally softer than those made by conventional lighting methods, and often needs printing paper one

grade more contrasty, or the adjustment of development technique to give more contrast in the negatives. Close examination of the prints often reveals a miniature umbrella in each eye. The purist might like to rectify this by stippling with sable brush and lamp-black until small soft-edged catch-lights remain. In any case, since the umbrella light tends to give rather large catch lights it is often a sound idea to reduce the size of these by means of retouching.

Apart from the obvious advantage of being able to carry a simple port-able lighting to home or school or office, the para-flash also provides an excellent fill-in light for the conventional studio in conjunction with a main, 'direct' light and possibly a back light to pick up hair detail, and a light on the background. I am sure the photographer of my childhood memories would have welcomed the modern para-flash – small and light in weight, yet allowing a stop of $f16$ at the speed of the flash which in my own case is about 1/600 sec.

Fill-in flash outdoors

In bright sunlight, dark shadows can be illuminated by means of a fill-in flash – either bulb or electronic – from the camera position. This technique will, of course, attract the child's attention, so that only one shot is possible as an unseen observer. But it will be justified where a good picture would otherwise be ruined because of lack of detail in the shadow areas.

Fill-in flash must remain subsidiary to the main light and the balance between the two must be carefully calculated. Two forms of control are open to you. You can vary the shutter speed, thereby affecting the amount of exposure given to the daylit part of the subject without altering the effect of the flash, which is usually of shorter duration than the action of the shut-ter. Or you can alter the distance of the flash from the subject, thus affecting the intensity of the flash without changing the daylight element in the lighting.

A problem with focal plane shutters, however, is that they cannot gener-ally be used with electronic flash at a higher shutter speed than 1/60 sec. or in a few cases, 1/125 sec. because at faster settings the shutter blind does not uncover the whole film area at any one time. Variations in shutter setting for all practical purposes would be only between 1/30 and 1/60 sec. with this type of camera.

To calculate for a basic exposure setting, perhaps the best procedure is to make a normal setting as for a straightforward daylight exposure and then divide the guide number of the flash and film combination by the lens aperture. This will give you the distance at which the effect of the flash and daylight will be equal. But since the ratio of sun to flash must be something like four to one the flash must be at least twice as far away from the subject than the distances calculated. A simple alternative is to keep the flash at the calculated distance from the subject but reduce its output by placing a handkerchief over it. If you are using colour film, the handkerchief must be white. The handkerchief can be folded to reduce the flash even further.

As a fill-in light to supplement daylight the best position for the flash is on the camera, near to the lens. But when used as a main light source, either to simulate sunlight on a heavily overcast day, or indoors when the available light is unsatisfactory, modelling will be considerably improved if the flash is on an extension lead and held, at arm's length above and to one side of the camera.

We are all familiar with the freak results due to leaving the flash attached to the camera as a main light source with little or no fill-in, in the manner of many press photographers. We have seen the background shadow outlining the figure, protruding ears and the pop-eyes. But occasionally this is the only technique available to us. When the famous Swiss photographer Werner Lüthy noticed the look of wonder on a little boy's face as he watched a cow being milked, the lighting problem could hardly have been more difficult. Herr Lüthy had a flash attached to his Rolleiflex and quickly seized his opportunity (page 106). In this instance the light source had to be as near the lens as possible so that the light could get under the cow and between its legs onto the child's face. This is an example where the flash-on-camera method was not only justified, but the picture could hardly have been obtained by any other means.

4 Child Behaviour Patterns

No two children are alike. But it is useful for the photographer to have some knowledge of the accepted four development phases of the young child. Not only will it assist him in handling children, it might also indicate aspects of the child's personality worthy of interpretation beyond the mere recording of a likeness.

Motor behaviour The child develops bodily control such as balancing, sitting, standing and grasping. Muscular co-ordination enables him to pick up or reach for objects.

Adaptive behaviour The child develops his understanding of the objects around him, firstly by exploring them with his mouth and later, as his ability improves to co-ordinate hand and eye, by reaching for and manipulating them. Gradually he learns to relate what he sees to what he feels.

Language behaviour The child learns to communicate visibly and audibly and to understand what is said to him.

Social behaviour The child learns to adjust to the social culture of his environment.

Behaviour at different ages

The infant His movements are mostly reflex responses – uncoordinated and negative movements such as 'jumping' at a sudden loud noise. Food is his main concern. He gets angry if he is kept waiting for it, secure and contented when he has had it. But his mouth is also his principal means of learning about things. He explores with his mouth, thinks with his mouth and expresses his feelings with his mouth.

Photography at this stage is mostly confined to the conventional record shot, christening-gowned and lying on a shawl. But close-ups taken with the camera looking down from a high angle are often effective. Some infants smile for the first time at about a month. He is fascinated by lights, amused by squeaks and sometimes smiles if you run your finger lightly round his lips.

Too young to swear Here is a very cross young man of four or five weeks. Crying is the only way he knows to get some attention. He is probably protesting about being disturbed, or about a tummy-ache. He may just be annoyed because he is unable to manoeuvre his thumb into his mouth. Or he may just feel that he is being neglected. He is very quick to learn that

a timely bit of howling will get people running around to attend to his creature comforts. If he feels like an extra feed, or a nurse, he will try it on now and again.

If he feels like a nap when his mother is dressing him or when you are attempting to photograph him, his expressions of disapproval would make a Covent Garden porter blush if they could be translated. There is nothing for it at this stage but to see to His Majesty's creature comforts if you wish to photograph him looking reasonably contented. See that he is fed but not 'fed up'. See that he has a dry nappy and has had his nap. If he still cries, he may feel he needs a little love. The little ones like love to be reaffirmed. Let his mother nurse him a little.

There is little fear in the young baby's make-up but he will be quick to sense if he is in uncertain hands. Always handle him firmly, supporting his head. In the first month he is not likely to smile but he will be fascinated by lights and will look where a noise comes from.

Sometimes he will be so bored by your concentrated efforts to amuse him that he will yawn and go off to sleep. If you wake him he will exercise his lungs again. But only because he is too young to swear.

Master Three-Months A quite different child. He can now hold up his head quite firmly and he finds his fingers fascinating. He can hold a rattle and likes to make a noise. He can turn his head to watch things that arouse his interest. He can now be photographed sitting fairly upright supported by pillows in a chair. Or he can sit down beside his mother who can support him safely by holding his clothes firmly at the back. Her arm may be hidden by a pillow. I find this the most satisfactory way of supporting baby at this age for both full-length and close-up shots. Now he chuckles and coos when you play with him.

Master Eight-Months He can now sit unaided for a few moments. He shows interest in many toys. He can reach out for things and understand things you say to him. You can photograph him on his tummy now, for he can hold his head erect. Or you can put him in a swing – almost sure to make him coo with delight. He expresses his feelings with frowns or smiles. And he is ready to enjoy a bit of fun with you.

Master One-Year Can be photographed standing if he has a chair to hold. His interest can now be aroused with building blocks and simple manipulative toys and anything with wheels. He will sometimes display his special

achievements such as clapping his hands and reaching upwards when his Mummy says, 'How big?' He is fully aware that these little tricks cause amusement and he is prepared to repeat them over and over to remain the centre of attention. From now on there is no limit to the ways he can be photographed and he will delight you with all manner of unexpected responses and actions.

Toddlers Between one and two years the child becomes more independent and extends the skills he has learned in his first year. He now shows interest in books and can turn the pages. He can speak up to 200 words and if you point to certain pages in a book he will identify a 'doggy' or a 'pussy'. He can walk and run and climb. He must find out things for himself and frequent tumbles are a big part of his education. He is determined to do things for himself. I have found that he will often resist if you try to sit him on a box about two feet high, but if you have a small flight of two or three steps leading up to it he will delight in climbing up himself. At some point in this stage of development he will probably have a cautious phase. He might even be extremely suspicious and uncooperative for a while. In fact this stage is possibly the most difficult the photographer will encounter. You have to call on your reserves of tact, patience and experience. If he accepts you he will love to play ball with you or watch glove puppets or to join in a conspiracy to surprise mummy.

Three to five It has been said that if a three-year-old cannot be photographed there is either something wrong with the child or the photographer. This may be an oversimplification but this is one of the easiest stages. It is as necessary now as ever to understand and be sympathetic to the child's problems. His assertion of independence inevitably brings him more and more into conflict with his parents who must frustrate him, sometimes arousing intense anger and even hatred for short periods. Try to remember your own feelings of littleness and inadequacy in a world mostly occupied by people more than twice your height.

Fortunately children in these pre-school years are often more cooperative with strangers than with their parents, who often express surprise that their offspring have been 'so good' for the photographer. The main problem for you now is liable to be a growing self-consciousness in the child and a reluctance to reveal natural feelings and reactions. The importance of play to act out these children's problems and frustrations cannot be overstressed.

Schoolchildren Are little persons. Conversation must now play an increasing part in our attempts to get through to them. Do not 'talk down' to them. Treat them as individuals capable of reasoning with their own particular brand of logic.

Sub-teenagers Gawky, moody, self-conscious, inarticulate, given to daydreaming and melancholia, these young people are a puzzle to older generations. Obsessed with the desire to be as unlike their parents as possible, many of them become very conformist, dressing and behaving alike, possibly through feelings of insecurity. If you are to ingratiate yourself with them you must make great efforts to understand the tensions that haunt them. While they are still almost babies in your eyes, you have to stand by helplessly and see them conform to the latest cult in dress and make-up and way of life. The attractiveness of the innocent child disappears, to be replaced by imitation adulthood. In the school playground or later in the discotheque they are about as sensitive as a herd of wild elephants.

But in the studio, nervous habits and such natural outlets for tense feelings as lip-biting and tongue-chewing, can make the task of portrait-taking difficult. If you bear in mind the tension created by competition at school, sometimes increased by overambitious parents, and tensions brought about by disagreements with parents and brothers and sisters, you might find it easier to be a little more sympathetic. I believe that children in this age group often have a deep conscience which is disturbed by their instinctive urge to defy parents and fight with other children in the home. There is also an awakening awareness of sex with its puzzling implications. Little girls tend to be embarrassed by the subject, but little boys often giggle over naughty stories.

The main purpose of outrageous behaviour in children approaching their teens seems to be to shock parents. The only way to get them to reveal their true selves to the camera is to get them to talk about a subject dear to their hearts. All little boys are interested in cars. Little girls love animals (more than babies at this age) and all of them are interested in records and pop music.

Eyes of a child

Is there anything in the world more beautiful or expressive than a child's eyes? They are also the key to the situation if you are trying to make a

child-portrait. As little Peter (or Anne) eyes you cautiously from the security of his mother's arms, he is weighing you up. . . . He is two years old, usually the most cautious age. A false move or word on your part at this stage and his deep-rooted suspicions about unfamiliar people and things might appear to be well founded and hopes of a good picture could be washed out in a flood of tears. Here is a challenge. You have to gain his confidence.

Your expression, your tone of voice, your general manner, must all suggest friendliness. Your first quiet words to him are a test of his reactions. Two bright eyes give you the answer. Suspicion, wonder, delight, alarm – whatever the message, it is a true reflection of his feelings. Any attempt to part him from Mum by so much as three inches at this stage might well prove disastrous as far as picture-taking is concerned, until you discern a hint that your friendly overtures are being accepted.

When his expression softens and the suspicion melts away, when the eyes flicker into the merest suggestion of a smile – then the child has accepted you. The key to the situation is in his eyes. They give you the go-ahead signal and from that precise moment the sitting can become a game and you may begin to gently impose your will on him to do the things you want him to do and which he finds he enjoys doing after all.

Eyes are windows through which children look out on to a strange world, a world of wonder and danger and peopled by giants. But windows can be looked through both ways. And we must strive constantly to see and understand the child's world of fantasy and fears, a world of discovery, a strange place where anything can happen. No single thing can help us to understand children more and to photograph them successfully as the ability to project ourselves into their world. The only way to understand difficult behaviour, and to be tolerant and patient, is to try to see through the eyes of the child.

Conversation

Your friendliness is communicated to a child by visual and oral means. The very young baby is hardly aware of you, being first attracted by bright lights and later by colours and sounds. Your first conversation with him consists mainly of squeaks and finger-snapping, but, when you talk to him he will recognize warmth and sincerity in your voice long before he understands the meanings of the words.

Children playing among the
war-ruins of Madrid. Picture
by Henri Cartier-Bresson, one
of the greatest living
photographers. *Magnum
Photos, U.S.A.*

(*Top left*) The smallness of a child in relation to his environment is emphasized in this picture by choice of horizontal format and inclusion of moorland setting. *Norman Clarke, Britain.*

(*Bottom left*) Child portrait taken by low evening sunlight giving good modelling against shaded background. *B. Fearnley, Britain.*

Diane, is a child picture which conveys a social message. *Sheilah Latham, Britain.*

(Left) *Mitgegangen.* A
fleeting picture opportunity
quickly siezed. *Leopold
Fischer, Austria.*

*Ringelreigen Unter Dem
Frühlingsbaum*, catching the
pastoral peace of the photo-
grapher's native country.
Werner Lüthy, Switzerland.

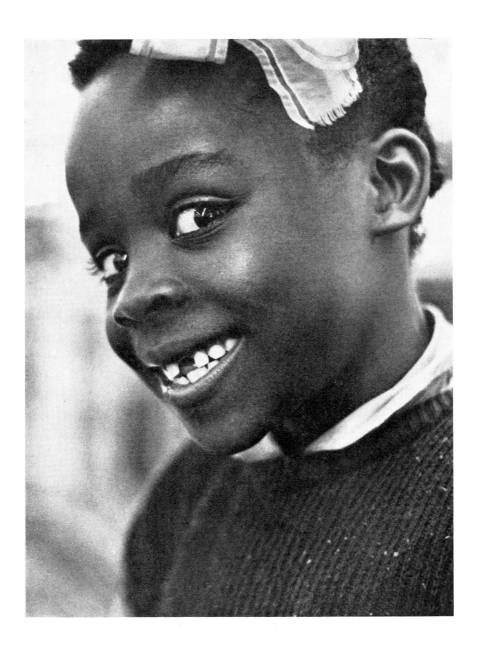

Indian boy, *Yuen Kok-Leng,*
Malaysia.

Monica has an appeal in spite
of awareness of the camera.
"Monica is a natural model",
says Miss Latham. *Sheilah*
Latham, Britain.

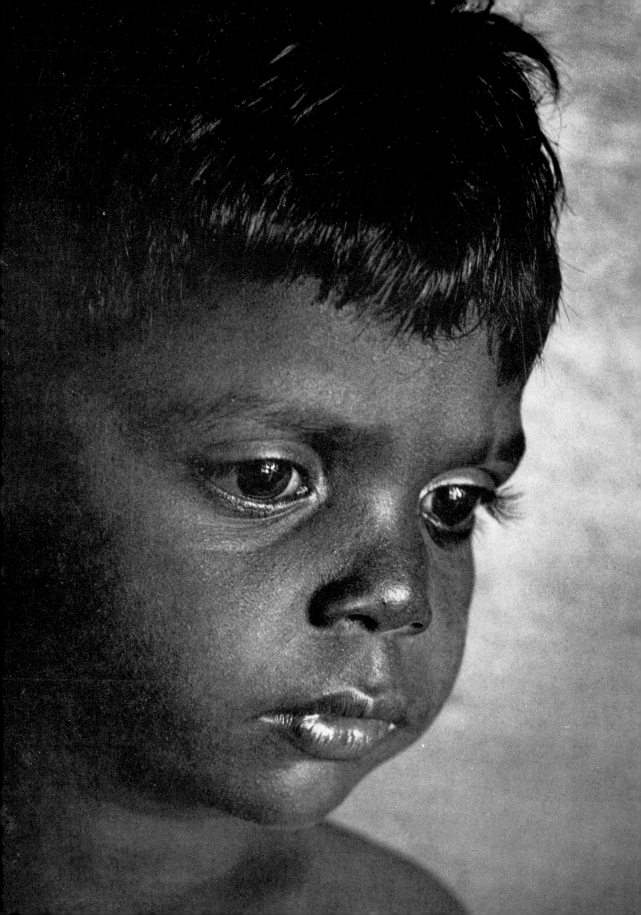

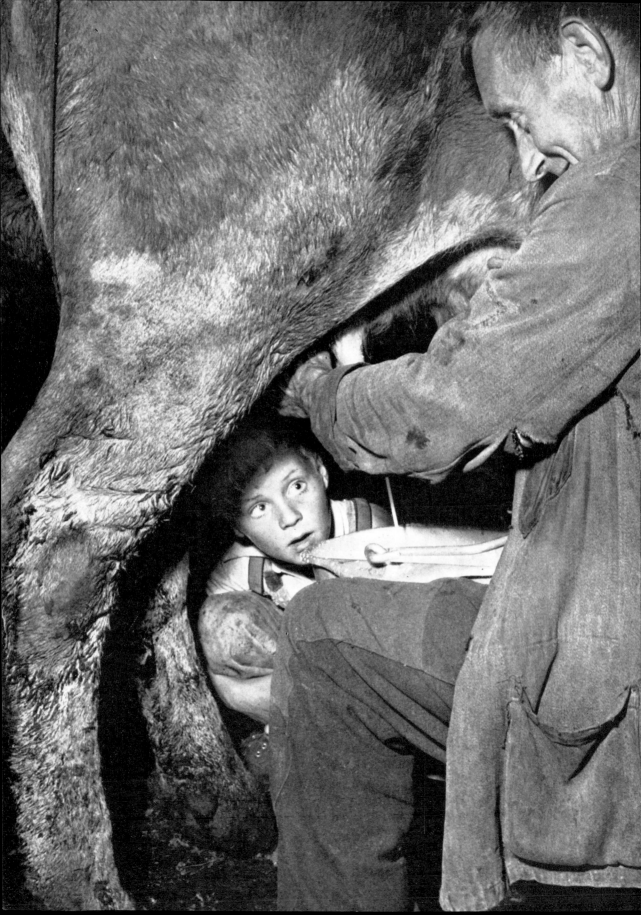

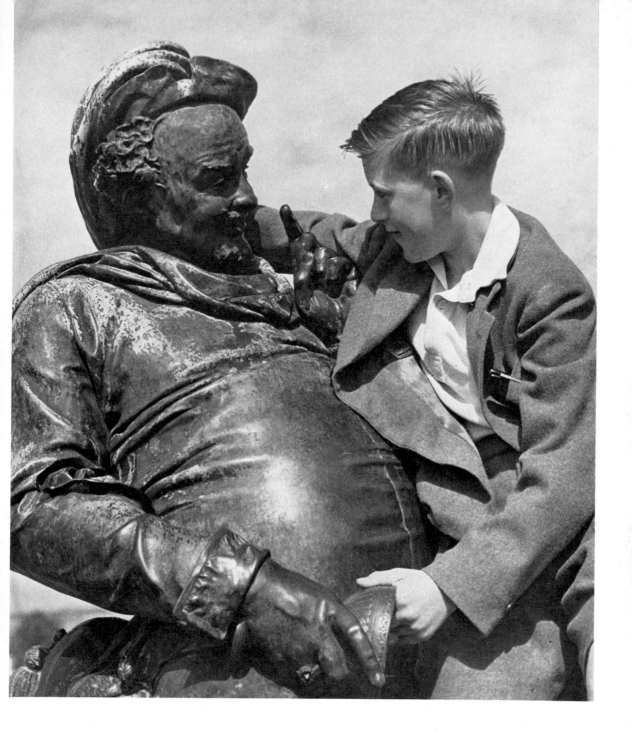

(*Left*) *Das Wunder im Kuhstall*, catches the wonder of a child making discoveries in a strange world. *Werner Lüthy, Switzerland.*

In this shot taken at Stratford-on-Avon, Falstaff appears to be remonstrating with the young boy for climbing on the famous stomach. *B. Fearnley, Britain.*

The charm of childhood
captured in this picture by
Desmond Groves, Britain.

(*Right*) There is almost a
return to the Victorian style in
this reposed study. A strong
pyramid composition cannot
fail to combine the figures.
Desmond Groves, Britain.

The way we remember our
childhood. Adventure galore
in ceaseless sunshine.
A. Fearnley, Britain.

Meaningful expressions
caught in the eyes of two
young boys watching
from behind a rocking horse.
Taken in a classroom by
daylight through the windows,
supplemented by normal
room electric lights. *Hugh
Scamen, Britain.*

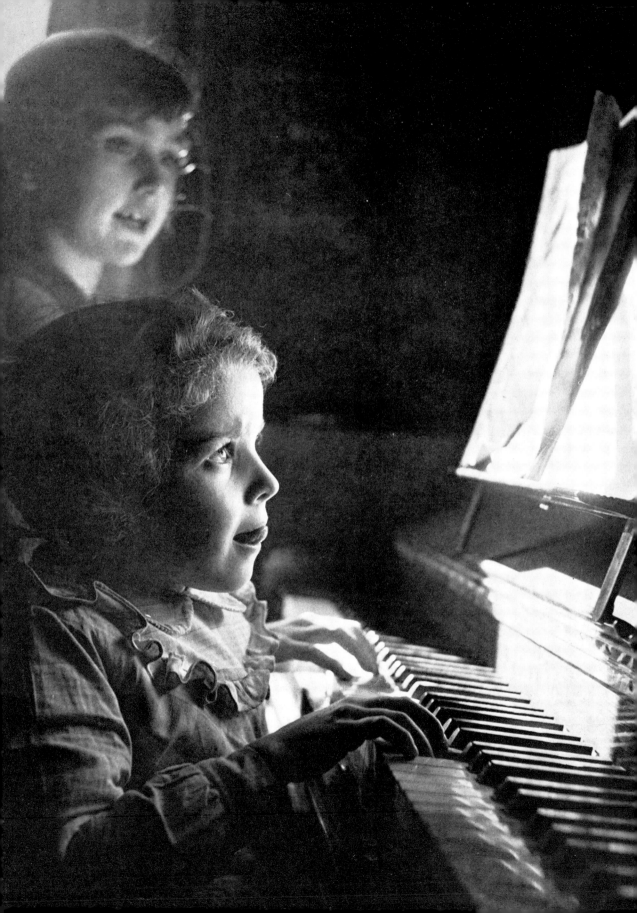

(*Left*) Sunlight through a
window and reflected back
onto the faces of the children,
plus the choice of the right
moment, made this a success-
ful child picture. *Robert
Doisneau, France.*

A perceptive eye spotted the
intense concentration on the
face of a little boy in a
children's orchestra. Carl
Zeiss used the shot in
advertisements. *David Davies,
Britain.*

72

The clean, high key Scandi-
navian approach to child
photography is epitomised by
this picture, by *Bertil Zerpe*,
Sweden.

Certain sights and sounds induce many babies to smile at about the age of one month. This is the beginning of a sense of humour which is later developed by means of play. He begins to understand the expressions on your face. Experiments have been carried out with 'smiling' masks and 'crying' masks. If you don a 'smiling' mask and look at a baby he will often return the smile. But the 'crying' mask only makes him anxious. It is wise to remember that a child will often reflect your own expression. Sometimes when I have been photographing a child laughing, I have deliberately assumed a serious expression and changed the child's mood.

Even when the child begins to understand the meaning of words, the manner in which they are said is far more important than the actual meaning. I have found that when I have photographed a Chinese or a German or a Scandinavian child who has not understood one word of English, it has only been necessary to employ the same methods and say the same things that I would have said to an English child. The response has been exactly the same. My feelings have been conveyed entirely by tone of voice. It is possible to say to a child 'You naughty boy' in such a way that will make him chuckle with glee. But by changing the voice inflection the same words can reduce a sensitive child to tears.

I never underestimate the intelligence of children or talk 'down' to them. Even the *volume* of your speaking voice is important. While one child may shy away from you if you speak above a whisper, another might positively revel in noise and may not even be aware of you until you raise your voice. With experience you grow sensitive to subtle indications of the kind of child you are dealing with, so that you can make adjustments in your approach to fit the mood and personality of the child.

A two-year-old bundle of suspicion can often be best approached indirectly. Thinking aloud or talking to a puppet will often convey your meaning without increasing alarm. It is sometimes said that 'little children have big ears', and take care that things are not said, to parents perhaps, but in the child's hearing, that could be misinterpreted. Little Jane's mother was concerned about a scratch on her little girl's nose, which she thought would spoil the photographs. I reassured her: 'A little re-touching will put that right.' Jane burst into tears and when pressed to give the reason, eventually sobbed, 'I don't want my nose touched.'

Conversation with a toddler should usually be a continuous cheerful chatter. But amongst all the questions about ages and names and favourite

toys and prettiest clothes, between the guessing games and pretending to be frightened by Sooty, slip in advance notice of any adjustments to lights or camera. For although most children find these bits of equipment the most fascinating things in your studio, it is possible that a nervous child may be disturbed by you handling them, and might even associate them with not dissimilar apparatus in hospital. It is safest not to make any sudden moves or noises. Approach the nervous child almost as you would a frightened fawn.

The schoolchild has passed through his cautious phases and gained self-assurance, as a rule. It is often better to have him in the studio on his own. The presence of parents might inhibit or embarrass him, but by himself, with a little prompting, his talk will be 'like a stream which runs with rapid changes from rocks to roses'. In his short life he will have accumulated knowledge of an astonishing number of topics. Ask him about his favourite television show, about pets, sport, school (with disarming honesty he is liable to tell you he likes playtime best, or 'going home'). Ask him about his holidays and what he wants to be when he grows up. I have had many an interesting conversation with a five-year-old. But do not offend him by talking 'baby-talk' or by playing a game that is below his intellectual level.

Make it a game

Play is important to the development of a child. It nurtures his sense of humour, develops his manual skills, increasing his self-reliance, and helps him to understand better the world around him. Playthings of all kinds, even empty cartons, blocks of wood or cotton reels, have great educational value. To a photographer of children, toys are tools second only in importance to the camera. You must regard play as your main ally in gaining the child's interest and friendliness.

You can succeed with children best by playing games appropriate to their phase of development. The average child from a few weeks of age, loves to be talked to or sung to. At three to six months he enjoys a few simple toys such as rattles and bells. He likes them to make a loud noise and has a distinct preference for the basic colours, the brighter the better. Pastel-coloured toys are made with parent-appeal. The child has not yet learned to appreciate subtler shades.

If he still appears to regard you as a monster, take refuge behind the camera and let a Teddy-bear work for you. It is sad but true, that a furry,

foam-plastic filled, glass-eyed representation of a bear-cub will often elicit a quicker response from the child than the face nature provided you with. Toys come and go, including replicas of the appurtenances of the Space Age, but dear old Teddy has come down to us from Victorian times and is still an almost universal favourite in his traditional shape. Almost, I say, because a few children have a phobia concerning all fur-covered toys. Some can even become hysterical at the thought of one touching them. So, even though the average child will gurgle with delight if a toy dog, or a bear, appears to talk to him or touches his toes, a watch must be kept for the slightest sign that the kiddie finds this kind of toy repugnant.

The nine-month-old child loves you to play Peep-bo from behind the camera. He delights in repetitive games and seems to gain some satisfaction from the fact that each time a game is played the result is exactly the same. He will solemnly watch you go through the play-routine several times, suddenly laughing at the third or fourth repeat.

As the child reaches his first birthday he likes to try out his manipulative skills and to satisfy his curiosity about shapes and textures, colours and sounds. Bricks and pegs and simple wheeled toys interest him. He will put most toys into his mouth, so make sure that all the toys in the studio toy cupboard are hygienic and too large to be swallowed or to get stuck in little throats.

From the second year, play develops the child's manual skills and sense perception, but even more important, satisfaction at his increasing dexterity gives him emotional stability. He will like to demonstrate his skill with a ball now, or look at the pictures in a book. Ask him to show you the picture of the kitten. 'That's not a Pussy, it's a Bunny,' you say. Your deliberate mistake will cause him great amusement.

I like to have shelves overflowing with colourful toys of all kinds, visible to the kiddie when he enters the studio. Most children are kept in an animated state of anticipation while I meditate aloud on which toy to take down next from the shelf. Children who have been used to putting on a demonstration to get what they want are liable to demand to be given one of the studio toys, and another, and another, *ad infinitum*. Such children are not content to watch toys as you manipulate them. And since you will get nowhere by transferring each toy from your shelves to the child's hands, only to be discarded and another demanded, there is nothing for it but to put all toys out of sight and try a different approach.

Probably the most useful toys in the studio are puppets of various kinds, glove puppets, string puppets and animated figures. Skill at manipulating these with one hand while the other hand holds the camera-release is useful and it is also helpful if you can design and make novelties of this kind. In these affluent days this is probably the only way of ensuring that you have novelties that are unfamiliar to the little folk.

If a child throws every toy down, either in temper or because he thinks it is amusing to make someone pick them up, hand him a ball and when he throws it try and catch it. Hand it back to him and say, 'That's a good game. Throw it again. I'll see if I can catch it.' He can often be side-tracked in this way into a game more likely to produce picture opportunities.

Often the most attractive thing to a child is the camera itself. I have seen small babies stare at my equipment quite fascinated and many toddlers reach out for it. An old camera kept as a play-thing is sometimes useful and many toddlers like to play at 'taking photographs'. Parents sometimes ask if they should bring a familiar toy to the studio – probably a particular favourite of the child. Usually I advise against this as we depend to a great extent on surprise and a child will usually discard its own toys in order to get hold of one he has not seen before. The unfamiliar is usually more exciting. In the case of an extremely nervous or cautious child, however, some confidence might be gained from the presence of a favourite toy, probably a battered animal and a bed-time companion. Such toys are alive in the child's imagination and he not only gives them affection, he also works off some of his frustrations on them. If the toddler is often at the receiving end of his mother's scoldings, the child in turn will sometimes scold poor old Teddy.

Imaginative play indulged in by the pre-school child serves an important function as a safety valve. Most children suffer some frustration and emotional stress at this stage and make-believe allows them to externalize some of their feelings and in this way relieve some of the inner pressure. Never ridicule this, but go along with it. Reality and fantasy are inextricably mixed up in the child's world and if we are to gain their confidence we must be prepared to believe, not so much in fairies these days, but in Indians, and space-men and secret agents – such is the influence of television.

You can use play to overcome resistance. You can use it to induce the child to do our bidding. If you want him to take something out of his mouth, to stand up or to sit down, to crawl, to put his tongue in or to do almost anything that he does not want to do, your only chance of success is to

devise a game, to turn it all into fun. Get him to *do* something, to participate in a guessing competition, to draw pictures, to read a book, to peep, shout, dance, sing. Make a game of it all.

Time factor

A child will not be rushed. He may warm to you in a minute, he may take half an hour. Each, according to his disposition, has a time-limit of acceptance of the unfamiliar. Any attempt to coerce him before he has made up his mind about you is courting failure.

When I first started to photograph children, with slow materials and exposures of up to one second, the main preoccupation was to keep the child stationary. I soon realized that if I could induce every child to smile and remain motionless for long enough to give me a sharp picture, I should please parents. Smile-getting became a habit, as if this was the only kind of expression worth recording. A special kind of technique had to be developed in which I imposed myself on the child, held his attention and enticed him to smile. Since the peak of the expression had to be caught in the middle of the exposure, a sense of anticipation and split-second timing became highly developed.

I also developed a sense of timing in my approach to the child – the little play-routines, the sounds and the jokes – almost in the manner of a comedian's timing for laughs. Smiles became synonymous with photography. And every day there were dozens of children defying me to make them laugh. It was like a game, pitting my skills against their defiance and it could be exhilarating when things ran my way, frustrating at other times. I felt like Gilbert's Jester:

> 'Though your head it may rack with a bilious attack
> And your senses with toothache you're losing,
> Don't be mopy or flat – they don't fine you for that
> If you're properly quaint and amusing.'

Thought associations

A little boy who cried in my reception room thought he was going to have a bath, which prospect he did not relish. He could hear running water in my film processing room, where a tankful of films was washing. To him, running water meant only one thing – a bath. This indicates how alive you

have to be to thought associations when dealing with impressionable little minds.

An impression in the conscious level of thought may be associated with a memory lying dormant in the unconscious mind. The memory can be connected with any of the senses. A child may take an instant dislike to you simply because of the colour of your tie. It may happen that the doctor who gave the child an inoculation wore one of similar hue. Smells, too, can have unpleasant associations for the child. Photographers use chemicals, for instance, whose smell might remind the child of hospital. Photographic assistants sometimes wear white coats which could add to the hospital association. Even without a white coat I have had little boys come into the studio holding up their arms for 'jabs'.

The sense of touch has associations, too. Some children soothe themselves by feeling the texture of a particular kind of material – maybe silk or lace.

Some thought associations are pleasant. I have heard of a photographer who claimed that his greatest asset when photographing children was that his face reminded them of a clown! Children loved to watch toys sliding off his shiny bald head.

An apparently illogical fear may be a 'memory' of before the child was ever born. It is said, for instance, that terror of animals has been traced to the mother being frightened by an animal before his birth. Such is the incredible and fascinating complexity of the mind.

Gentle persuasion

I have been kicked, scratched and bitten by children in my studio. They have even sworn at me. But occupational hazards of this kind are fortunately rare. Most children respond to gentle persuasion. Firmness on the part of parents may be necessary at times. Indeed I think that a child who is accustomed to being told unhesitatingly what to do by his parents usually gains in terms of security. But the photographer must use gentler methods, such as 'Can you climb onto this stool by yourself, Johnny, or would you like me to help you?'

Imagine what it must feel like to be two or three feet tall in a world in which grown-ups tower over you. Kneel, crawl or sit on the floor – but get down nearer to their level. And place them on a table-top or 'box' about eighteen inches high to level things up. You are much less intimidating when your head is at their height.

I remember an occasion when a little girl had to be persuaded even to enter the studio. She screamed with terror each time her parents tried to carry her through the door. She was about three years old and coaxing, threats, bribes – all were of no avail. At length her father realized that she thought she was being taken into a lift. She had had a frightening experience a year before, he told me, when a lift in which she was travelling with her parents had crashed to the bottom of the shaft, shaking them up badly. This was a case for appealing to the child's sense of logic. Opening the studio door wide I pointed to the fireplace. 'Did you ever see a fireplace in a lift?' I asked her. For a moment the little girl turned over this thought in her mind. But she was convinced, came into the studio and was soon playing happily.

Trying to think like a child, calling on every ounce of tact and patience you can muster – these things can keep you young. Or they can age you prematurely. It depends upon your temperament.

Parents

'Aren't parents a problem?' as Miss Five-Year-Old was overheard saying to Miss Four-Year-Old. 'Children begin by loving their parents,' said Oscar Wilde; 'after a time they judge them; rarely do they forgive them.'

Most of us, as parents, make many mistakes. We are overindulgent or neglectful, overstrict or too lax, overanxious or too indifferent. We can create an inferiority complex by expecting too much from our child or by belittling his achievements. Friction between parents can make a child feel insecure. On the other hand, displays of affection between them can create jealousy.

Pampering on the one hand, or heavy discipline on the other, are both equally undesirable. But the parent who vacillates between both extremes according to the mood is worst of all, creating feelings of frustration and insecurity. Parenthood is surely the most difficult profession in the world. Inevitably parents are blamed for all character aberrations and can be forgiven for thinking at times that they cannot win. All we can do is to be sensitive to our child's course of development, try to be understanding, bring him up in a happy home atmosphere, keep all our promises to him – and also our threats – teach him respect for other peoples wishes and opinions and try to find the right blend of freedom and control.

When introduced to an unfamiliar experience such as having a photograph taken, an insecure child may test the affection of his parents by resorting to tears or difficult behaviour. He needs assurance of the quality of their love. We can only deal with this situation by being understanding and sympathetic. But it underlines probably the most important aspect of bringing up a child. We must constantly bear in mind his need to be reassured of our love for him.

As photographers we must expect to have to handle a great variety of children with a diversity of backgrounds. Many will have been overprepared and overfussed by well-meaning mothers. Some may have been told not to smile because of gaps in their teeth. Little ones will have been told that the 'man will not hurt' them. Some will be wearing rehearsed smiles. Most will be dressed too elaborately. Fortunately, most children, when played with, soon abandon such adult-imposed artificialities.

Some parents seek the advice of the photographer regarding 'preparations' for a studio-session. This not only puts them on the right lines but also makes them feel more confident, armed with the feeling that they are approaching the 'sitting' in the right way. And some of this confidence will probably 'rub off' on to the child. When approached this way, the salient points to stress are as follows:

Do not tell young children beforehand that they are going to be photographed. You want the sitting to be a lot of fun – not an ordeal.

Infants are in their best humour after a nap and a feed. Choose the right time of day for the appointment.

It is wise not to have friends present as they tend to distract the child. Do not tell the kiddies to smile, sit still or be good. Such instructions only increase a child's natural caution.

For clothing, it is better to have something light in colour and texture, to complement the natural charm of childhood. Familiar clothes should be worn, even if not new, and younger babies are best photographed without shoes and socks. Schoolboys should not be dressed too stiffly. Sportswear will make them feel more at ease.

Hair should not be altered or bows and ribbons added for the occasion. Simplicity is the key-note in child photography. Nothing should detract from such a wonderful subject.

But the best advice of all is *do not fuss.*

I know of one photographer who added a further piece of advice, but one

I consider inadvisable; Will all progressive parents please keep their children on a leash.

From school age children usually respond more readily if the parents are not present in the studio. A proud and often anxious mother may cause some embarrassment to the child and her gaze might inhibit him. But with younger children it is advisable to have the mother close by. I sit her close to the baby. An audience of relatives and friends, all anxious to help, can be extremely distracting and you sometimes need to exclude them from the studio as diplomatically as possible. Even the kiddie's mother, who naturally feels that she can induce expressions better than anybody else, has occasionally to be restrained from making a series of clucking noises, or, with older children, entreaties to 'smile as you said you were going to.'

I usually sit the child with his back to the mother for several reasons. Firstly, the model (key) light is placed on the side the child is facing and therefore her shadow will not fall on the background behind the child. Secondly, if the child overbalances it will usually be backwards and the mother is in a position to catch him. Thirdly, he will not be able to see his mother's face, and although he will be confident because he knows she is close, you will hold his attention more successfully. It is essential for the kiddie to watch your face so that you can control the angle at which he looks, coax out an expression and anticipate the moment of exposure.

Sometimes when you are happily capturing a series of entrancing expressions from a child, his mother may be urging him, 'Oh come on. Smile like you do at home.' Unfortunately, your pictures will usually be judged by the amount of smile you managed to induce. Mrs. Gripman says that when a mother of a two-months-old baby comes to the studio she says, 'He must laugh. He's always laughing at home.' Says Mrs. Gripman, 'It's hard to refrain from asking "Even when he has tummy ache?"'

'If he cries the mother is quick to say, almost as if a button had been pressed, "I don't understand it, he *never* cries." Sometimes grandmother who accompanies the little wonder to be photographed will give instructions how it is to be done and how the child shall be made to laugh – because the child *must* laugh.'

Photographing the green-eyed monster
He hit the studio like a small tornado. The air was filled with yells, coaxings, scoldings, threats and screams. He had to be restrained from dismantling

the camera. He kicked his mother on the shins, violently rejected all the toys offered to him and finally threw himself on the floor stamping and screaming. He was two and a half. His nine-months-old sister viewed his performance with amusement cooing angelically. 'Oh, Christopher, look how good Baby is,' said his mother.

The day had been disastrous from the start, just when mother particularly wanted the children in a good mood for the photographer. Christopher had started by tearing up the morning newspaper. Dad had gone to work in a rare temper, glad to escape the bedlam. On the bus journey to the studio the lady who had her hat knocked off had said to the lady who had the contents of her shopping basket scattered, 'I know what I would give *him* if he were mine.'

Christopher is on the studio floor in a tantrum – a situation brought about by feelings of jealousy for the baby. 'But he loves the baby,' mother sometimes protests. And in apparent confirmation of this, he sometimes puts his arms round the baby and gives her a rough kind of kiss. He has learned that this little party-piece is a hit with grown-ups and earns him words of praise.

Resentment of the new baby does not always manifest itself in such an extreme fashion as in Christopher's case. His parents having prepared him carefully for the new arrival, he coped with the situation fairly well at first, until the baby had to go into hospital for a spell. Now he had his parents to himself again and he enjoyed the situation. But when the baby was brought home again and became the centre of attention and fuss, the little boy felt left out in the cold once more. One has to try and imagine what it is like to be the first-born, enjoying both parents' undivided love and attention, only to find that suddenly there is a rival for their affections.

Even with understanding parents, seldom is jealousy not aroused. But if his hostility is driven underground by unfavourable comparisons with the baby, or by excessive punishment, fear of losing his parents' love will cause him to act in any way that will draw attention to himself. He might feign illness, indulge in showing off, or resort to temper-tantrums. He would rather be thrashed for his bad behaviour than feel he is being neglected.

Attempting to understand the causes of bad behaviour is half the battle. Most personality misfits of this kind are due to psychological patterns in the unconscious mind. Once we accept this we are liable to be more patient and to find an answer to our problems.

Let us ask ourselves what Christopher feels he needs most. The most important thing in the world to him is to have his mother's love for him re-affirmed. Ignoring his noisy demonstration for the moment, concentrate on gaining acceptance from the baby. Now take her on to your 'posing' bench and ask the mother to take the little boy on her knee and nurse him. This may take some time, because when a child has made a demonstration he often does not like to give way or to 'lose face'. But the prospect of a display of affection from the person who is the centre of his little world is usually too good to miss.

As the little boy's rage subsides and he snuggles into his mother, peace reigns again. So far, so good. Continue to direct your attention to the baby, playing with her, getting her to laugh. Take one or two shots of her. Bring out a selection of toys and spread them around the baby. The older child, now reassured and already feeling more secure, will notice that the baby is having a whale of a time. Perhaps he is missing some fun.

Move your camera back to allow space for him beside the baby in the picture-area. He must not be rushed. Attempts at persuasion might put him on his guard again. Wait until he shows signs of wanting to join the baby in the game. If you have plenty of time and patience you will still get happy pictures of the pair playing together.

Caution

Little Carol was a timid child. 'She won't play with other children,' her mother said. She looked at me with large frightened eyes and clutched at her mother's clothes. She withdrew into her shell as soon as she entered the studio. She backed away from a proffered toy as if it might bite her. As long as she was away from the blanket of security represented by the familiarity of her home and her mother, her only desire was not to be noticed. The world terrified her and she thought that if she kept quiet maybe she would not get hurt. Her pre-occupation was to survive.

Most children go through a cautious phase at some point in their development. This is usually at about two years of age but it might be at one; but most children have grown out of it by the time they are three. During this time, which might last a few weeks or a few months, the child views all unfamiliar places, people and experiences with great suspicion. When inoculations have to be given to the child at this oversensitive stage, the

effect on their minds can be serious and long-lasting. Even a visit to the hairdresser can be a frightening ordeal. The photographer, who has not merely to avoid frightening them, but to win their confidence and evoke some response, has no easy task.

With Carol, who had a cautious nature, or with a child who is merely passing through a phase of suspicion, the approach is much the same. Do not make any sudden moves or sounds. Speak quietly. Then slowly and patiently try to thaw the child. Remember that caution, frustrating though it can be, is a natural phase of development and in years gone by was a condition of survival for the human race. If our primeval ancestors had not been cautious they would probably have been eaten by wild animals.

Little Carol is not faced today with the same dangers. But the feeling survives. White-coated men stick needles in her. Strangers rush at her and snatch her up out of the security of her cot. A door bites her finger. Just keeping alive seems to be a full-time occupation. So treat her gently. Let her contemplate you from a safe distance for some time before you make any advances.

Temperament and complexes

'Hello, little man, what's your name?' I asked a kiddie of about three years. 'I'm not telling *you*.' he said, scowling. The toy I offered him was thrown back at me.

Aggressive behaviour, of which this is, I consider, a *mild* example, is usually due to inferiority complex, which is unconscious and not to be confused with an inferiority feeling, which might be a good quality involving modesty and incentive for improvement. An inferiority complex can be caused by a number of things including *excessive* restriction of a child's natural urge of self-expression, setting too high a standard of behaviour, or later, of achievement at school, consciousness of a disability or anything which sets the child apart from other children, or lack of affection from parents.

'Can you give me a clue about your name?' I persevered. 'How does it start?' This found a chink in the little boy's armour. He could not resist the temptation to show off his new-found ability to spell. 'It begins with a D', he said, a little petulantly. But by the time I had made a few wrong guesses and he had finally spelled out his name for me, he had thawed out and become friendly.

Introvert and extrovert

Jill peeped at me warily from behind her mother's skirt which she clutched tightly in her small hand. Oversensitive, this little girl was motivated by fear and suspicion and took refuge in sulkiness. This is also often the result of an inferiority complex.

The main temperamental types are the introvert, like Jill, who lived within herself, and the extrovert who tends to show off or become aggressive. The results of inferiority complex vary according to the temperament of the child. The introvert creeps further into his or her shell, becomes morose, sullen and anxious. The extrovert tends towards boasting, antisocial or neurotic behaviour. This child may do and say things with the sole object of attracting attention to himself.

Jill's main desire is to go unnoticed. She feels that if she keeps quiet or hides she will not get hurt. There is no easy way to win her cooperation; it requires a long, patient, quiet struggle. It sometimes helps to leave her in the studio with her mother for a while. If her mother introduces her to some toys and novelties you have left with her for the purpose, when you peep in a little later she may have thawed in your absence. In extreme cases of this kind I sometimes set up my lights, leave a small stool on which I hope the child will sit later, focus my camera on the stool allowing some space round it and place another stool beside the camera. I quietly explain to the mother that I am going out and that she can help me by first playing with the child and quietly getting her onto the stool, ostensibly to play with a ball, then sitting on the stool beside the camera and continuing to amuse the kiddie with glove puppets or anything that catches her interest. My studio is so designed that I can be seen by the child to depart through the door, but can enter unseen later by another door and can observe her in a cunningly positioned mirror. I can also operate my camera from this vantage point by means of a release several yards long which I have previously fitted. Although I prefer only to use this method as a last resort, there have been occasions when, with the help of a cooperative mother, we have obtained pictures that could not have been taken any other way.

I have noticed that a carry-cot represents security to some young babies of a cautious nature and that they often show signs of anxiety when lifted out in the studio. In such cases it is a good idea to take some shots of the baby in the cot. Some good pictures can be had like this and baby will feel safe. Quite possibly, after the kiddie has weighed you up from the familiar

and secure comfort of his cot, he will allow you to lift him out for some different pictures later and all will be well.

Tempo

The tempo of a sitting may have to be varied to suit the particular child. Little Jane is round, friendly, amiable and lazy. Her principal hobbies are eating, sleeping, and making friends. The key to success with her is to slow down and let her do things at her own lazy pace. Jonathan, on the other hand is a live-wire. He is active, excitable, likes movement and will be difficult to keep pinned down long enough to focus. You may have to chance him being in the picture area and take some extra shots to make sure. Your only chance with Jonathan is to move even faster than he does, get excited yourself and make the whole session a fast-moving romp. A few like Jonathan in a day can have you 'on your knees'.

If a child takes a look at you and looks like running away do not look in a mirror to ensure that you have not grown horns or an extra head. Nothing is more exasperating than to be treated like a monster from outer space by a small child when your only desire is to be friendly. Your best hope is to try and understand the reasons underlying his behaviour. To be able to identify a child's particular temperamental type can assist you to find the approach most likely to win his cooperation. But a further complication is the fact that few children are entirely introvert or extrovert, most being a mixture of the two in different proportions. The introvert child may suddenly surprise you by allowing his curiosity for the studio to submerge his apprehension. On the other hand, the normally extrovert child may suddenly and unexpectedly develop a fear of the camera. But caution, curiosity, wonder, surprise, even defiance, shown in a child's expression, all offer wonderful picture opportunities. And with patience, the smile the child's mother is hoping you will capture, may eventually present itself.

5 Methods of Approach

'Stalkers' and 'Directors'

Photographers of children fall into two categories. They are either 'stalkers', attempting to remain unnoticed by the child, or 'directors', starting with a preconceived idea and exercising control of every detail of lighting, setting and handling of the child. Both methods require a great deal of patience. The stalker may have to wait hours or days or weeks for his picture. The exponent of the director method needs a reservoir of patience to cope with children of varying ratios of resistance and cooperation upon whom he attempts to impose his will. At least some knowledge of basic child psychology is necessary here.

The stalker technique is epitomized by the work of Henri Cartier-Bresson whose pictures are eloquent comments on life. His perceptive genius enables him to observe unseen and to anticipate the significant moment. His Leica, covered with black tape to make it inconspicuous, is virtually an extension of his eye. He is a spectator of life, the world his studio. As he roams, he constantly analyses each situation. Few people notice the patient little man with a camera in his pocket.

He uses a minimum of equipment which he keeps out of sight as much as possible. His subject is generally 'people' but children appear in his viewfinder at frequent intervals. He never communicates with them or influences them in any way. He waits, and waits for them to reveal themselves. A gesture, an expression, an attitude are observed sharply. The subject is seen in relationship to the surroundings – children just being children whether it be in the back streets of Paris or among the war-tortured ruins of Madrid or wherever their actions can be caught and used as a forceful means of expression.

It would be impossible to find a greater contrast to the Cartier-Bresson approach than that of Francis Wu in Hongkong. He is the complete director, starting out with a preconceived idea and working out in advance every detail of composition, lighting and costume. Exploiting the whimsical appeal of slant-eyed Chinese children in story-pictures, often with a humorous twist, he has had considerable success in the salons of the world. By sheer force of personality he imposes his will on the children to coax from them the desired mood and expression.

Working in the studio, his equipment is elaborate. The lighting is multiple flash with up to eight flashheads, working from a single power source with booster which gives guide numbers of 180–360. This lighting set-up

gives him greater speed and depth of focus, even working with a view camera with five-by-four inch format, than is usually enjoyed by miniaturists in day-light. Yet he achieves the undoubted superiority of definition and quality of the larger format. His camera line-up is impressive. He uses various view cameras and roll film single lens reflex.

After Francis Wu had given extra-mural photographic courses at Hongkong University, the students became so interested that they formed a camera club which has become one of the most successful in the world. His wife Daisy, who was born in Honolulu, has also won an international reputation for child pictures. She met Francis during her college days. Finding herself married to a man whose consuming passion was photography she soon became infected with his enthusiasm and in 1954 won a 2,000-dollar American contest with a picture of her two boys looking out of a misty window and called, *Waiting for the Sun*. She now has eight grandchildren.

One of the many clichés concerning child photography is the oft-repeated assertion that children can only be photographed successfully in natural surrounding. My quarrel is with the word 'only'. Cartier-Bresson the stalker and Francis-Wu the director produce pictures that are brilliant in their different ways. And between these methods are endless variations.

'Candid' photography

The word 'candid' was first applied to photography in 1929 when Dr. Erich Salomon first used a technique of working unobtrusively by available light with a hand-held camera, and a fast lens. Although usually associated with the miniature camera, the term 'candid' refers less to the type of equipment employed than to the method of keeping the subject unaware of the camera. Studio pictures of children can often be said to be candid, even when taken with a large plate camera, if the child is caught off guard as he should be. In the artificial atmosphere of the studio a photographer must employ psychological methods to cut through the selfconsciousness of the child, draw his attention away from the camera and induce him to reveal something of his true self. At the moment of exposure the camera should be completely forgotten. Practically all successful studio pictures of children, apart from in specialized applications such as advertising where child models are used virtually acting a part, are 'candid' in the sense that the camera is forgotten.

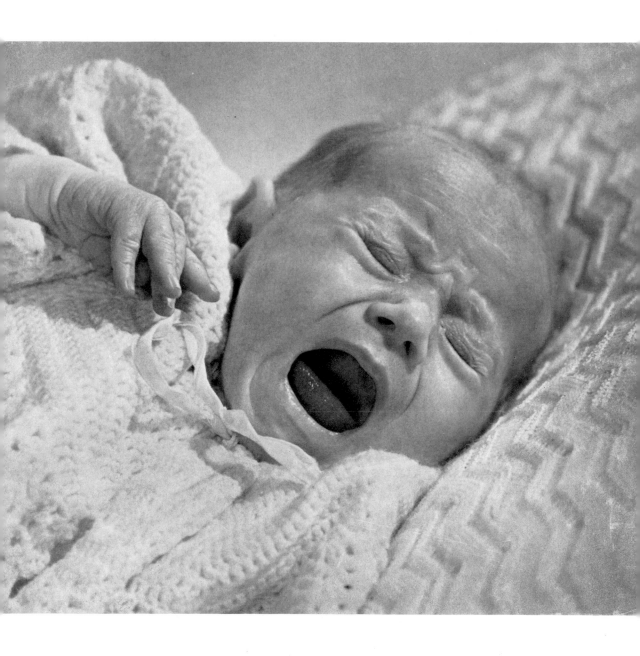

Too young to swear, but able
to make his own kind of
demonstration. *B. Fearnley,
Britain.*

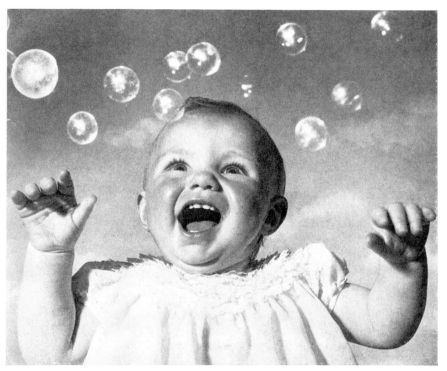

(*Top*) Exhibition pictures made in the darkroom. The "bubbles" were taken on a separate negative. The two negatives were then sandwiched for printing.

(*Bottom*) Contrasting expressions of same child, taken within half a minute, printed in one picture. *B. Fearnley*.

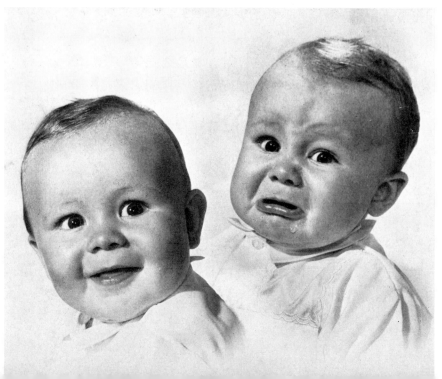

It's the expression that counts—four examples.
(*Top left*) Stiff Upper Lip.

(*Top right*) Delight.

(*Bottom left*) Curiosity.

(*Bottom right*) Uncertainty.

B. Fearnley, Britain.

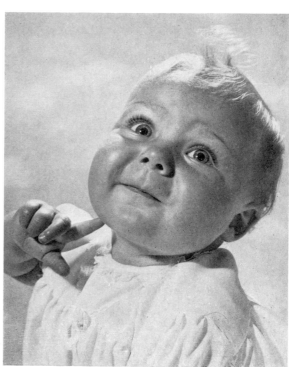
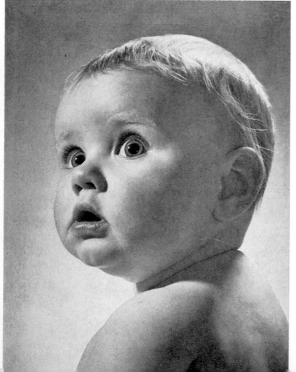
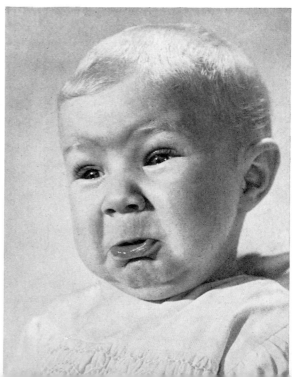

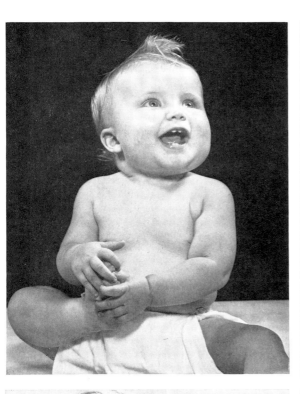

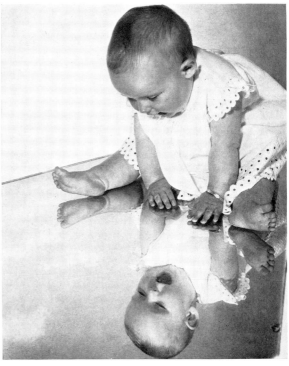

(OPPOSITE, *top left*) The way the cookie crumbles. The child removes crumbs from between his toes, where they were placed by the photographer, who is also a psychologist. *Josef A. Schneider, U.S.A.*

(*Top right*) Hello, Reflection. *B. Fearnley, Britain.*

(*Bottom left*) Bright Eyes. *B. Fearnley, Britain.*

(*Bottom right*) Disdain. *B. Fearnley, Britain.*

(*Above, left*) Peep Bo, by a photographer who tries to make herself "as old as the child" in her studio. *Ann-Marie Gripman, Sweden.*

(*Right*) Whoops. Electronic lighting and quick reactions made this a "well-balanced" picture. *B. Fearnley, Britain.*

Winsome. Taken with electronic speed-lights as described in the lighting chapter. *B. Fearnley, Britain.*

(*Top left*) "Look, Mum, There's a man with a camera." Taken with four speed-lights. *B. Fearnley, Britain.*

(*Top right*) A studio session should be lots of fun, and for mum, too. *B. Fearnley, Britain.*

(*Bottom*) Tell Tales. Lit with photofloods. *V. A. Belgamkar, India.*

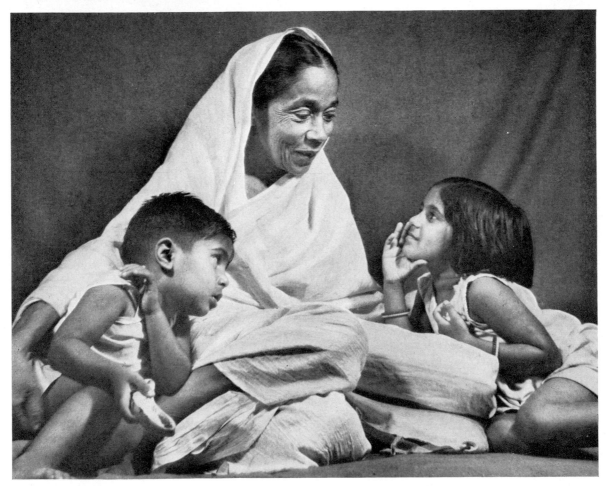

(*Left*) A fresh approach to an
eternal theme, mother with
child. Taken with photo-
floods. *Robert Whiteside,
Britain.*

(*Top left*) A child's hands are
so expressive: *Food For
Thought. B. Fearnley, Britain.*

(*Top right*) *Bless Me.
B. Fearnley, Britain.*

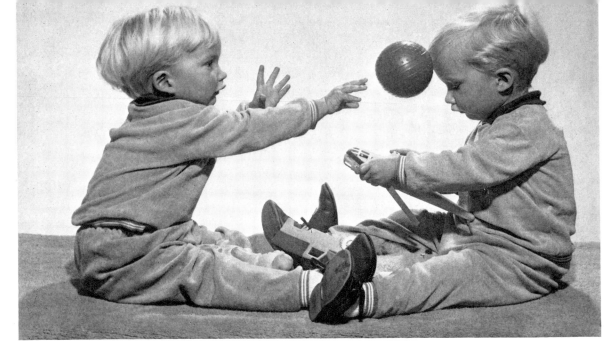

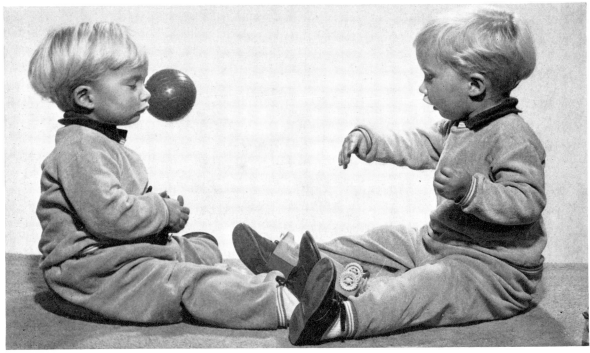

Tit for Tat. A camera with a quick wind and re-set mechanism was necessary here, in this case a twin lens reflex and anticipation on the part of the photographer. *B. Fearnley, Britain.*

(OPPOSITE, *top left*) Children are children—East or West: Malay girl by *Yuen Kok-Leng, Malaysia.*

(*Top right*) English schoolboy by *B. Fearnley, Britain.*

(*Bottom left*) Maid of Norway, by *B. Fearnley, Britain.*

(*Bottom right*) Chinese schoolboy by a well-known Hong Kong photographer. *Daisy Wu.*

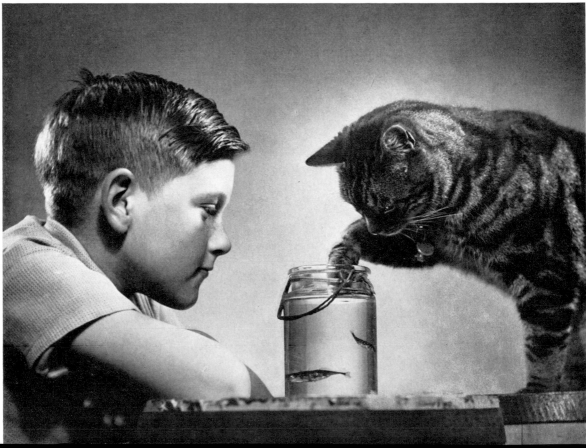

(*Top left*) Picture planned in detail in the studio to a pre-conceived idea. Sisterly Secrets. *B. Fearnley, Britain.*

(*Bottom left*) *Fishing companions*, also a planned composition. *B. Fearnley, Britain.*

Since the world of the teenager revolves round 'pop' here an attractive young miss is photographed with her favourite L.P. records. The antique gramophone was printed in from a separate negative to satisfy the younger generation's craving for 'gimmickry'. *B. Fearnley, Britain.*

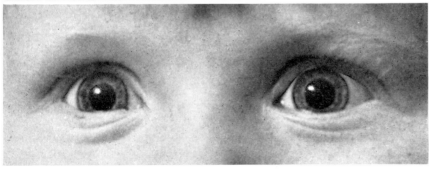

In photographs taken with Paraflash, enlargement of eyes reveals umbrella-shaped catchlights.
(A) Paraflash as fill-in. Secondary catchlights barely discernible.
(B) Umbrella-shaped catch-lights where the Paraflash was used as main light.
(C) Umbrella reflections re-touched to disguise shape, leaving smaller, soft-edged catchlights.

(OPPOSITE, *top left*) Taken with a four-flash studio set-up, with the Paraflash as fill-in.

(*Top right*) Used as a fill-light, the Paraflash was here far enough back to keep the secondary catchlights small and not recognizable as miniature umbrellas mirrored in the eyes.

(*Bottom left*) Same subject with umbrella-light as sole illumination in room with white walls.

(*Bottom right*) Again taken with Paraflash only, and twin lens reflex. *B. Fearnley, Britain.*

Maria-Louisa a talented young
Spanish dancer, photographed
with dramatic up-light to
create mood in keeping with
the fiery character of the
dance. Taken with main
spotlight near floor.
B. Fearnley, *Britain*.

Children in natural surroundings

To photograph children without their knowledge requires only a minimum of equipment – just a camera and a means of calculating exposure. Needless to say, it also requires of you much patience, a 'seeing' eye and an instinct for anticipating a picture. Inevitably, because of the unpredictability of both subject and lighting conditions, particular attention must be paid to technical considerations. To keep your camera correctly set for the prevailing light conditions and to keep your highly mobile subject in focus without attracting attention, calls for some foresight, initiative and concentration. The opportunity for a picture, once missed is seldom repeated. Experience is the best teacher.

The unseen approach

It is fatal to be 'fiddling' with gadgets at a time when pictures are liable to be offered. Wherever possible, meter readings should be made in advance. Train yourself to be aware of lighting changes, adjusting the lens a stop or so one way or the other as required. Even at the risk of making an error of exposure, put your meter in your pocket and forget it for a while. More pictures are missed because of a preoccupation with gadgetry than because of technical miscalculations. Practice handling the camera controls until they become almost instinctive. The press-photographer sometimes sets his camera at a predetermined distance, say ten feet, and then endeavours to keep this distance between him and his subject. This method can be handy with children where the magic moment might occur just as you are checking the focus.

The advantages of the 35 mm. camera for this type of child photography are obvious. But the twin or single-lens reflex are preferred by some people for reasons that may not be so obvious. For instance, these cameras allow you to observe the child while you appear to be looking in quite another direction. You can even turn your back on the child and operate the camera backwards under your arm, or sideways at waist level. You can hold it above your head and use it like a periscope to see over a crowd.

The 6 × 6 cm reflex camera is more difficult to conceal than the 35 mm. type. Perhaps the best way is to have the camera on a neck strap resting on your chest and partly hidden by a slightly open jacket. Automatic film transport and a quiet shutter are highly desirable.

The 'electric eye' camera which automatically judges the brightness of the scene and sets the aperture by means of a photo-electric cell will free you from the worry of a technical failure, provided the limitations imposed by this method are fully recognized. For instance, in 'contre-jour' (against the light) shots, since the exposure will be read over the entire picture area, you are almost certain to get a silhouette of the child against a strongly lit background. If this is not the effect required, it is often possible to develop a technique of half covering the cell window of the meter with a finger in order to increase the exposure for the shadow detail of the face. But this is rather a 'hit-or-miss' method calling for a degree of experiment.

The ideal photographer of children by the unseen method would obviously be able to render himself invisible. If this is beyond your abilities, you can certainly help by dressing conventionally and without eccentricities, working in a leisurely fashion and keeping your camera out of sight until the very last moment. If the child becomes aware of the camera pointed in his direction, the best thing is to turn the camera away and go through the motions of photographing something else. The child will soon lose interest in you and return to his game. Occasionally the moment of awareness makes the picture.

Such an occasion was when Leopold Fischer, a Viennese police photographer who has earned a considerable reputation for salon pictures throughout the world, paid a visit to Bergdorf Kals in East Tyrol on the occasion of a religious festival. He noticed an attractive little girl in traditional costume, looking diminutive between adults similarly attired. As he watched, the little girl turned and looked enquiringly at his camera. Fischer took the picture 'mit blitzschnell', as he eloquently expressed it.

The unseen photographer cannot exercise any control over his subject. But he influences the result by choice of angle, background, lighting and moment of exposure. To move the camera a foot to the left or right, up or down, can profoundly alter the mood or impact of the picture. The background should be unobtrusive, but not necessarily blank. Often it is desirable that it suggest a natural environment for the child, as long as this does not compete with the main subject. Strong contrasts of tone and hard lines can be disturbing in the background, especially when the child appears to have a plant growing out of the top of his head or a window sill shooting into his ear.

A low camera viewpoint will sometimes place the child against the sky.

The beach often provides an effective uncluttered background from a high angle. Fussy backgrounds, such as with sunlight glinting on dark foliage, should be put out of focus by choosing wilder apertures, not forgetting to give a compensating increase in shutter speed. Differential focusing in this manner is often to be preferred with close-up portraits, although in full-length work, the activities of the child must be seen in relationship to the surroundings and therefore depth of focus is necessary.

Light outdoors

Light diffused by cloud normally presents little difficulty as there are no pronounced shadows and pictures can be taken from almost any angle. Observe, however, the effect of reflection from light areas in the scene and take advantage of these where possible. In direct sunlight it is safer to have the sun behind you and to one side of the camera, but more interesting effects are to be had with strong side lighting or with the sun almost facing the camera. In these cases a lenshood is essential and exposure must be calculated with special care.

When departing from frontal lighting the child's face may be partly or wholly in shadow. A useful trick for obtaining an exposure reading in this situation is to hold your hand vertically in such a way that the light on it resembles that reaching the child's face. A meter reading taken say, about six inches from your hand will give a quick and fairly reliable indication of the required exposure.

The long shadows of early morning or evening, especially in summer-time add considerably to the relief effect. Avoid sunlight directly behind the camera or at its height in summer. Both these conditions, producing short shadows, give 'flat' results. A photograph I took of my son at the age of three, in a cliff-top garden, with the sunlight coming across the sea from near the horizon gave almost the illusion of having been taken in a studio. A privet hedge in shadow and thrown out of focus, added to this effect.

Composition

While the beginner may be glad enough just to get reasonably sharp and clear pictures, later he is likely to pay more attention to the subject himself. As he progresses he will become increasingly aware of the potential of his

camera as a means of expression. Experience will show him that the camera is more than a recording instrument. It is capable of portraying emotional experience.

Creative photography is influenced by the subjects we have already touched on – lighting, camera angles, background and choice of the moment of exposure. Of equal importance is composition, a subject so complex that only those aspects having a particular bearing on child photography can be treated here.

To be able to recognize a picture when it presents itself and choose the significant moment of exposure requires a perceptive eye. But to give the picture the maximum impact and expression you need to cultivate a *selective* eye. Life produces a constant kaleidoscope of accidental groupings of objects from which the photographer must select well-ordered patterns. Firstly he must simplify by leaving out all non-essentials. Strong lines which cannot be avoided must be organized to lead the eye to an important part of the picture.

Look objectively at the subject as if you are seeing it for the first time. Ask yourself what you wish to say about it. Your feelings about it can best be expressed by emphasis, putting stress on some parts of the picture and 'soft-pedalling' others. Children have a strong visual and emotional appeal and it is often only necessary to isolate the subject from the surroundings by careful selection of angle and lighting to eliminate distractions, or by differential focusing to diffuse practically all the picture except the child.

An advantage enjoyed by the studio photographer is that he can select his background, which can be lighter or darker than the subject as long as it is unobtrusive. High key or strong counterpoint lighting against a dark background – either can be effective. When children are photographed in natural surroundings, at play, out of doors or in the home the problem of what to include and what to eliminate is more difficult to assess. Many objects demand inclusion but would dominate the result. What devices are available to us to ensure that the child remains the main subject?

Firstly, tone. When the child is well-lit, if he is against a plain background of lighter or darker tone he will stand out sufficiently well. But other methods must be employed where other objects in the picture compete for our attention. We have already noted that differential focusing can place emphasis on the child by making him the sharpest part of the picture. We can also make him dominate the picture by being the *largest* feature in it,

although this is not always desirable since the very *smallness* of a child has pictorial possibilities.

As to the arrangement of tones in the picture we can eliminate unnecessary detail by using a long-focus lens, or getting close or perhaps using a low viewpoint to get rid of a confusing foreground. As child photography in natural surroundings involves a strong element of opportunism, often with little or no time for compositional analysis, a degree of control is still available at the darkroom stage. Unwanted detail can often be cropped-off, shaded-out or fogged-in during printing.

Next, the subject must be related to other elements in the picture area. Lines should lead the eye into the main subject. Generally speaking, lines which traverse the picture lead our interest out of the frame unless transversed by opposing forces.

The subject can gain in emphasis by being placed at a strong pattern point in the picture, such as the centre of a circle, or perhaps framed by the dark shape of a doorway. A most useful strong point in common use in child portraiture is the apex of a triangle. This pattern establishes a sense of stability. In a three-quarter-length picture of a child the body often forms the triangular shape with the face as the centre of interest at the apex. Balance is often a matter of personal taste and the photographer must sometimes obey his instincts in this respect. There are, however, one or two rules which must be observed almost invariably. Remember that light areas tend to draw attention to themselves. Keep the child away from the centre of the picture or the edges but allow more space in front of him if he is looking to one side or the other. In other words, see that he is looking *into* the picture and not out of the side. Horizontal lines suggest peace and tranquility; verticals stand for strength and stability. Diagonal lines are active and energetic.

Although these fundamentals are generally followed it would be a mistake to suppose that a picture which breaks any of these rules must be a failure. Many great masterpieces of painting have flouted the accepted rules. Sometimes a picture can succeed in spite of its violation of accepted standards, simply because of the strength of its subject matter. The rules should certainly be learned. But it is more important to cultivate an awareness of the interplay of lines and surface and values in our everyday lives. By mentally organizing the form of these values we can give better expression in our pictures to our conceptions and emotions. Thus an instinct may be

developed for selecting well-ordered patterns which add impact to the original picture conception.

Children at school

With thirty-six exposures, or even twelve, in the camera there is a temptation to shoot indiscriminately. Writers on child photography often advised taking many exposures, in the belief, presumably, that with a large enough quantity, there are bound to be a few good shots at least. But it *is* possible to have thirty-six indifferent pictures on a roll, and, although I am not against taking many pictures, I believe that no exposure should be made without at least a quick survey of the situation in relation to its picture possibilities.

A photographer wishing to remain an unseen observer, must study the child's movements and expressions. You must recognize when a group of children promise to create an interesting situation. You must anticipate the development of the situation to its natural climax. You must, in effect, survey the happening from the outside, taking pictures, changing the viewpoint, striving for improvements until all the important factors fuse into a good picture. Your first set of rough prints must show a progression and improvement with each shot leading to the one which caught the essence of the situation.

This kind of approach is put across in the more progressive art schools today. Students are encouraged to use the camera to increase their awareness of the world in which they live. Even in primary schools, children are given cameras and sent out to make photo-essays. These youngsters will not be content to take snapshots with a box camera. They are using photography as a means of communication. They have been called 'the Young Communicators'.

For the younger viewpoint, I contacted Hugh Scaman, a student at Leicester College of Art, England, who had had photographs of children accepted for a Kodak exhibition of students' work. I learned that he had ambitions to be a photo-journalist. He regarded young children as good photographic subjects because they were not old enough to be self-conscious and were not concerned with the image they were putting over. 'They are full of vitality,' he said, 'not yet having learned to invent worries. They are too busy running, playing, laughing or shouting or sitting quietly alone or perhaps with a friend, so completely absorbed as to be oblivious of the camera.'

On the whole, the children Hugh Scaman has photographed have not suffered from camera-shyness. He has found that if a child behaves shyly all one has to do is to make a great show of photographing someone else. Whereupon the 'shy' child looks disappointed, indicating that the apparent shyness was a form of exhibitionism. Sometimes children are too keen to be photographed and stop their play to come crowding round his camera. He finds it is no use shouting at them. This is the time to talk with them. They eventually leave and continue their game. Except, that is, for the die-hards whose heads will appear on every second frame. 'These cheeky show-offs sometimes make the photographs,' he says. (In my own experience they usually spoil many pictures, since they are only too well aware of the camera and assume deliberately false expressions.)

Scaman considers that a lens of a wider than normal angle is ideal, especially where there is little room to move between rows of desks in a classroom or where one is surrounded by children. He thinks the 35 mm. reflex camera has the advantages of eye-level viewing without risk of parallax error, and the camera allows many frames to be shot in rapid succession. But his particular camera has the drawback of an extra loud shutter which makes the children aware of his presence, even in the early stages. His photograph of the two children peering cautiously from behind a rocking-horse was taken on fast film with normal development in MQ. It was taken with the classroom lights on and sunlight coming through the windows.

He is reluctant to use flash because it attracts the children's attention too early. There are always things to photograph in class but one must not interfere with the teaching. This would be ill-mannered and would lose the validity of the scene. He is unstinted in his praise for teachers. 'Photographing in a school,' he says, 'gives one some idea of the problems and the pleasure of teaching.'

Another representative of the younger school of photographers is Sheilah Latham, radiologist turned photo-journalist who regards photography as a natural extension of her consuming interest in human nature. She did not set out consciously to specialize in child photography, but, because of their wonderful lack of inhibitions, children do tend to form the major part of her work. She uses two single lens reflex camera bodies with a full range of lenses, which she finds a convenient and versatile method. She always uses available light.

Many of her pictures, like 'Diane', tug at the emotions. The defiance on

the child's face, on which is imprinted the mark of neglect and deprivation, make this a strong and moving comment. Many of Sheilah's pictures speak eloquently of social problems. But sometimes she will post herself with shutter cocked and senses alert at a strategic point, perhaps at a pedestrian crossing or in a children's hospital. Delightful series of uncontrived pictures result. Sometimes the camera is spotted, as in 'Monica'. This attractive little girl, a natural model, responded with a happy, toothy smile.

Sheilah Latham has been very successful in international exhibitions. But she continually studies the latest advances in technique to keep abreast of the newest practices. That fact, plus her instant recognition of a situation and her spontaneous reaction to it, make her work outstanding.

Rapid movements

Sometimes blurred images suggest action more effectively than pin-sharp ones. But if a moment is to be caught from a movement and held, sharp and clear, some thought must be given to the shutter speed required to achieve this. You may be trying to freeze the animated gyrations of children at play in poor light which restricts you to relatively slow speeds. The following facts may serve as a guide.

Suppose the child is running across from side to side at something like four to five miles an hour and about a dozen feet from the camera. A speed of 1/200 sec. is needed to arrest movement. If the child is on a round-about, or trotting on a pony, or cycling, you may well need to set your shutter at 1/1000. If the lighting conditions are bad this might be out of the question. But these times presuppose that the background is also to be sharp. But if the camera is swung, or panned, with the moving child, speeds as slow as 1/30 can be used, after practice. The resulting blur of the background suggests speed more effectively than the picture in which everything is sharp.

Slower shutter speeds may also be used if the child is moving towards the camera or even diagonally across the picture area, rather than parallel to the focal plane. In some cases fast movement can be stopped by careful timing of the moment of exposure. A jumping child, for instance, if caught at the peak of the jump, is momentarily still, before starting the downward movement, and relatively slow speeds may be used to catch this moment. This also applies to a swing or sea-saw at the peak of the movement. I was

once able to freeze an equestrian act, full of violent movement, in the relatively poor light in a circus tent, with a shutter speed of 1/30 sec. Three horses galloped round the ring, a pyramid of men and girls on their backs. The picture was taken as they reached the left-hand side of the ring and, for a brief moment were galloping *towards* the camera.

Movement can, of course, be stopped by flash, but here we have been mainly concerned with taking pictures without the knowledge of the children.

A child aware of the camera

Mr. Yuen Kok-Leng, A.R.P.S. of Malaysia often uses the verandah of a house to take close-up portraits of Indian and Malay children. In countries where the sunlight is strong and steep, it is sometimes difficult to get pleasing half-tones and Mr. Kok-Leng uses light reflected from the ground and walls to achieve delightful portraits with beautiful modelling and skin texture.

His child subjects are aware of the camera and consequently he has to seek their co-operation with patience and understanding.

'I first try to make friends with children by getting to know them,' he says. He tries to win them over and finds sweets a useful aid to this purpose. Gradually he introduces the camera, allowing them to get familiar with it. After a while the children forget the camera and he begins to make some exposures. He says: 'Children will not be rushed. Treat them as equals and do not let your talk be patronizing. Get them to do something and join in their games.'

In the home

Available light in the home can be difficult to work by with a moving subject and the child may move from patches of strong light coming through the window into pools of deep shadow in corners or beside pieces of furniture. The simplest working method is to keep the child near the window. Persuade the younger ones to play on the window-ledge with toy cars or bricks. Sunlight can give a pleasing rim-lighting to a child in profile, absorbed in his game. Older children may be looking through the window or reading a book. Try going outside and take pictures of them looking in, possibly through rain-spattered glass.

Inside again, when the child near the window turns towards the camera you will need to get some additional light into the shadows. This can be provided by fill-in flash (as in some outdoor sunlight shots) by a photo flood on a stand, or a reflector, which can be a piece of hardboard or plywood of convenient size painted white or covered with metal foil. Even a book or newspaper will reflect some light into a face. A child plays the piano with an air of deep concentration while another child looks on. The sunlight streaming through the window strikes the sheets of music and is reflected back to pick out the expression on the face of the young and earnest musician. Robert Doisneau, the brilliant French photo-journalist grabs the picture. He had to shoot quickly because the expression came 'immediatement'. Most of his child pictures are taken in the streets of his native Paris. They often reveal his delicate sense of humour and an eye for the incongruous.

The bounced flash technique is useful in the home. Direct the flash on to the ceiling or a light-coloured wall instead of the subject. The result is a pleasantly diffused light which, because of its evenness allows the child greater freedom to wander about the room. Except where pieces of furniture cut off light reflected from walls, you will be able to take pictures wherever the child roams and be sure of a soft even lighting, particularly suitable for young children. Remember to open the lens at least three stops for this method, which is only suitable for colour if the walls and ceilings are white. A photoflood in a reflector can be used in this way with equal success.

If there is a fireplace in the room, a photoflood placed in it will give convincing 'firelight' pictures, with the children in pyjamas grouped on the hearth-rug.

Two photofloods on portable adjustable stands widen the scope of photography at home. One can be kept near the camera and well-diffused while the other is used as the principal modelling light and is moved about and positioned to give 'roundness' to the face and, at the same time, avoid shadows cast by furniture. A small spotlight used high and behind the child will add lustre to the hair, but this has to be used cautiously. Stray light from this lamp must not be allowed to fall on the forehead or tip of the nose. You are often better off without it when a baby has little hair or is very fair. Otherwise you are liable to have burned-out highlights and a bald look, which the mother will not like.

As the lighting grows more elaborate you need to exercise greater control over the child, probably confining him to a particular area in the room

where the lighting is set up. Often, you have to rearrange the furniture, and it is certainly advisable to remove all knick-knacks and ornaments. If the wall is plain you are lucky, but it is more likely to be decorated with a strongly patterned paper. The one room where conditions are usually conducive to good child photography is the bathroom, where the walls are not only plain and light, they are also highly reflective. Consequently one light, be it flood or flash, is sufficient, as it bounces about from wall to wall producing good modelling. Children often enjoy bathtime and make delightful pictures at play in the water. But even here, objects such as taps can intrude.

Children also like to be told bedtime stories and here is another delightful picture-subject. Inspector V. A. Belgamkar, C.I.D. photographer of Bhopal, India, took his successful exhibition picture of an old lady reading to two young children, with a Rolleiflex and photofloods. Indian houses often have plain white interior walls, so backgrounds there are less of a problem than in the modern European house.

Inspector Belgamkar tells me that he used a diffusing filter for the picture, which he titled, *Tell Tales*. He tries to create a 'homely' atmosphere and never orders children about. 'After a while,' he says, 'they find suitable poses themselves but it requires patience.' As an escape from the sordid photography he is called upon to do in the course of his police duties he likes to photograph pleasanter things to make exhibition pictures. India abounds in camera subjects, but children are 'the most easily available. Even if I spend a little time getting the right pose and expression,' he says, 'it is a real recreation for me to live for a while in the innocent world of children.'

Is psychology really necessary?

They are brought to my studio in all kinds of mood. Boisterous children. Children crying, laughing, sulking, eager, suspicious. Happy children. Obstreperous children. Most are a joy to play with and to photograph. And it must be admitted at once that these are often the ones whose parents take psychology with a pinch of salt, or at least keep it in perspective. Many of them would say that they use 'plain common sense' in bringing up their children.

But the percentage of 'difficult' children seems to increase as the years go by and one is bound to have doubts as to the success of methods urged by child psychologists over quite a long period. There is little evidence that

children are better adjusted than formerly or, indeed, that the children of an affluent society are any *happier* than the underprivileged, sometimes bare-foot, children of yester-year.

We live in a society geared to the needs of the young. The surprising thing is that so many of them, resisting a positive bombardment of undesir-able influences, grow up unselfish and with some moral integrity. For most are encouraged to get their own way, by any means in their power, almost from birth. Any form of control is considered repressive. And yet I do not think any responsible psychologist has ever denied the need for discipline for people living together in a civilized community. 'Freedom of expression' is a phrase used to excuse bad temper and selfishness. In extreme cases, so called 'progressive' parents will give junior a hatchet if he expresses a desire to smash up the piano. After all he is only 'working off his frustrations'. In their desire to bring up their children in a modern manner, parents eagerly swallow garbled pop-psychology as served up through the mass-media, adopting the jargon to impress their friends, and usually missing the real point of psychology entirely. The most important lessons of all, tolerance and respect for other people's wishes, are omitted.

While one would not like to see a return to anything like Victorian heavy-handedness, nevertheless, it is now obvious that *complete* lack of control results in more unsure, frustrated, and discontented children than ever before. Is there any validity then in the oft-repeated assertion that pho-tographers of children need to be psychologists?

Some fortunate people have the heaven-sent gift of being able to win the confidence of almost any child. They regard psychology as so much 'mumbo-jumbo.' They succeed simply with absolute sincerity and love of children. They have the ability to make everything into an exciting game and sweep the children along with them on a wave of fun. I know of one such person who loves and is loved by all children. In the studio, even the most stubborn of children respond instinctively to her. She does not 'spoil' them, in fact she is quite firm, but she generally manages to bring out the best in them. She would not regard herself as a psychologist, yet she is probably one of the best. If you have this instinct for handling children you have no need to read psychology. But you are one of a very select band. Most of us find the behaviour of children inexplicable at times and turn to psychology for help.

Child psychology attempts to explain the child's behaviour and promote understanding. In this it is usually successful. It is less so, yet, in supplying

the answers. For it is a very young science and psychologists are still experimenting with our children, liable to reverse an opinion between one book and the next. Perhaps last year you were told that to say 'No' to a child was to make him feel unwanted and unloved. The book you are reading now might well tell you that it is even excusable and natural to lose your temper with the child. A child psychologist once told me that secretly he felt that applied psychology was best applied 'to the appropriate part of the anatomy'. And I confess I have seen the old-fashioned method work wonders.

As soon as you attempt to photograph children from outside your family circle and especially in the case of the professional who may have thousands of children brought to his studio in the course of a year, you will encounter children from a variety of backgrounds ranging from the most disciplined to the very 'permissive'. An interest in psychological theory will help you to understand difficult behaviour and consequently to be more patient, provided you remain open-minded about the subject and learn as much as possible from your experience. The studio provides an opportunity to observe the various types of reaction by children to the same set of circumstances. Train yourself to make mental notes and profit from each new point that arises in the course of each sitting.

6 Technically Speaking

Choice of camera

The photographer of children today is offered a bewildering choice of cameras and it is true to say that good child pictures are possible with practically all of them – even the simple model costing only a few pounds. Choice must be influenced by such considerations as whether you intend to shoot in colour or black and white, professionally or for family use, in the studio, in the home or out of doors (or all three) with flash, photofloods or available light.

In colour, for instance, if your intention is to take slides for projection, the 35 mm camera commends itself. Not only is this size of film economical, there is also a wide range of viewers and projectors. In this respect choice is much more limited with larger sizes. You are also offered countless cameras over a wide price range, with a variety of refinements such as reflex prism-focusing at eye-level and different methods of exposure calculation. This size of colour slide, besides being excellent for family records is also ideal for submitting to photographic salons. But for professional use, most editors or advertising agents will consider anything below $2\frac{1}{4}$ in. square too small – unless you *really* have a masterpiece.

For black and white work, the 35 mm. camera with high resolution lenses and today's superb fine grain films, is more than adequate. The 35 mm. frame can yield large prints provided the correct processing procedure is strictly adhered to. If you intend to 'stalk' your subject the ideal camera should be small enough to slip into your pocket, easy to set even in poor light, easy to focus, with a quiet shutter and interchangeable lenses. Henri Cartier-Bresson has found that his Leica, its chrome covered with tape to make it inconspicuous, has been more than adequate since 1932. He does not use a case but protects the lens with a cap. He mostly uses an *f*2, 50 mm. lens, but also carries with him a wide-angle 35 mm. and a 90 mm. lens.

The sub-miniature camera is easy to conceal, but I do not think it worthy of consideration by serious workers because of the restricted opportunity for technical control. It might provide some fun, however, and would certainly be useful to carry around with you, just in case you stumble on a picture in the course of the daily round. It is certainly small enough to slip in your pocket and forget about, until required.

Possibly the best size for universal use is the popular 6 × 6 cm. ($2\frac{1}{4}$ in. square) negative. In this size the choice is mostly between the twin-lens reflex and the single-lens reflex. The main advantage of this size over the

35 mm. is probably the ease with which a picture can be composed full-size on the focusing screen. Usually a magnifier is also provided for fine focusing, and in some cases, split image focusing, using the rangefinder principle, in a small circle in the centre of the screen.

The Rolleiflex, introduced in 1928, was the precursor of many similar twin-lens cameras. This type of camera enjoys great popularity with photographers of children, one of its advantages being that, in addition to the normal waist level operation which brings the viewpoint nearer to the child's level, the camera can be operated at eye-level (useful for fast action shots), or can be stood on the ground. This worm's-eye view is often particularly effective with children, as it enables you to use the sky as a background or to get down to those activities on the ground that children find so absorbing.

The modern twin-lens reflex is reliable and simple to operate with crank-operated film transport coupled to the shutter tensioning, and a barely audible leaf shutter (or similar) with light value scale and XM flash synchronization. Among many accessories are supplementary close-up lenses which can be used with children without undue distortion provided that you keep a watch to avoid such things as the hand pointing toward the camera. Versions of this type of camera are now available with interchangeable lenses, thus removing a former disadvantage and one reason for choosing a single lens reflex, instead. Parallax is automatically corrected, eliminating a fault in early models.

In each type of camera, faults are constantly being eliminated, making the choice more difficult. For instance, the single lens reflex formerly suffered because it was necessary, especially in poor light, to open the lens to full aperture to focus, since the image on the screen came through the taking lens and at small stops was very dim. It was then necessary to reset the lens to the correct stop before taking the picture. Now the iris diaphragm stays at full aperture for focusing and when the release is pressed the lens is automatically stopped down to the pre-set aperture before the exposure is made.

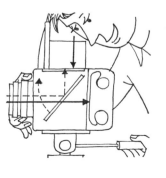

Modern single lens reflexes (SLR) such as the Hasselbad are fine precision instruments bearing little resemblance to their predecessors other than in general principle. Their main advantages are the range of lenses and interchangeable magazines, enabling you to switch from fine-grain to fast film or to colour in a moment. The least desirable feature as far as child photography is concerned is the focal plane shutter, which in some cases presents

difficulties when synchronized for flash and is loud enough, added to the sound of the mirror returning to its horizontal position, to attract a child's attention. But a leaf type shutter is now often incorporated in the interchangeable lenses.

One must weigh up the pros and cons of the different types of camera before buying, but appearance and 'feel' and, of course, price, must also influence you. Handle the camera before deciding. See that it fits easily into your hands and that the controls are easy to find. It may be a pleasing shape, but are you able to hold it steady at slow speeds?

Avoiding camera shake

Few people can hold a camera really steady at exposures of longer than say 1/60 sec. Usually the larger, squarer cameras are easier to hold steady than the lighter, more streamlined ones. On the other hand the focal-plane shutter usually found in the miniature camera stops a moving subject more effectively than the between lens leaf shutter. Generally, the longer the focal length of the lens the bigger the risk of camera-shake. It is always wise to take advantage of any support available – a wall, a tree, or even your face or chest. It is also a good idea to hold your breath during the exposure. With practice and trial and error until a suitable stance and grip are found, hand-held pictures are possible at speeds as slow as 1/25 or even 1/10 sec.

It may be of passing interest to note that of those who have contributed pictures to this book, by far the larger percentage used the 6 × 6 cm. format twin lens reflex. Surprisingly, perhaps, next come the large format cameras such as that working on a 5 × 4 in. format or specially designed cameras for studio use. In recent years, however, the SLR, in both 35 mm. and 6 × 6 cm. sizes has become the most popular camera for child photography although a noisy shutter and mirror return is still a disadvantage in some cases.

The best of both worlds

It is often said that the hand-held camera is best for child photography, because it gives you extra freedom. Yet it is difficult to get friendly with a child with a camera in front of your face or even at your waist. In the studio there is much to be said for the conventional set-up of the camera mounted on a stand and the child placed on a raised area restricting his movements

within a yard or two. But in place of the old juggernaut of a camera on a heavy wheeled stand, used by studio photographers in great-grandfather's day and still, unfortunately, by some even today, we now have a compact precision camera on a lightweight stand, readily adjustable to any height and angle. Marcus Adams is said to have disguised his camera as a doll's house, but this is no longer necessary. The child has grown up with cameras ('It's just like Daddy's') and will probably find it the most fascinating thing in the studio. Even small babies reach out for it and one day I shall put a long release in a tiny hand and young Seven-months will take his own picture.

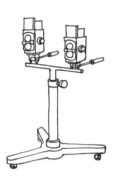

I have used Rolleiflexes in the studio for over twenty years, but some people prefer single lens reflexes because the film magazines allow quick changes from black and white film to colour. But, since the two types of film usually have different speeds, requiring also adjustments to the speed or stop, I prefer to have two identical cameras, one loaded with black and white and the other with colour film, mounted side by side on a specially designed bar fitted to the camera stand. In this way each camera can be correctly set for its respective film speed and is always roughly positioned with its twin so that I can switch from black and white to colour in a moment without losing continuity in handling the child.

If we add synchronized electronic lighting to this set-up we can enjoy the luxury of photography at $f16$ with a speed of $1/1000$ sec. or so. This will 'freeze' the fastest movement and it is almost impossible to have an unsharp image. One wonders what some of the great photographers of the past would have produced with this kind of technical advantage. With the low power model lights in the centres of the flash tubes you can arrange the lighting balance just as you would with tungsten floods. This illumination is sufficient to enable you to focus either through the wide aperture focusing lens of a twin lens reflex or a camera with fully open lens using an automatic setting to prearranged stop. A camera without such device, such as an older type SLR or stand camera, is at a disadvantage. This lighting requires such a small aperture that the image on the focusing screen would be extremely dim, and one should avoid constant adjustments to the lens aperture when photographing children.

By borrowing from the conventional studio photographer the advantage he enjoys of known and tested technical conditions, leaving us free to devote most of our attention to the child, and from the out-of-doors approach the

small easily operated camera allowing the child to forget its presence and play naturally, we can have the best of both worlds in the up-to-date studio.

Problem of distortion

While availing ourselves of the technical advantages available today, we should be unwise to abandon all thought of the past. If you believe that the photographer's role is merely to watch and wait, then sometimes you must be prepared for a very long wait. A child's hands, for instance, are expressive and often make a picture. But while you are watching they have probably gone as limp as an empty banana-skin and about as expressive.

When I was learning the rudiments of portrait photography in the Thirties the first thing I was shown was how to arrange hands and feet. There were certain accepted rules about this. Hands had to be carefully positioned in such a way that they did not make ugly or distracting shapes. Some of the light had to be shaded off them so that their light tone did not draw the viewer's eye. Legs were turned to the side and feet crossed away from the camera – to avoid foreshortening and distortion. Posing in this way is shunned today. And yet working with a small camera much nearer to the subject, it is now more important than ever to avoid distortion.

You must certainly see that the feet do not obtrude and that the child's hand, thrown towards the camera, does not appear to be larger than his face. You can, of course, use a long focus lens on your SLR or twin-lens reflex camera. But you must weigh the advantages of better drawing thus obtained against the psychological disadvantage of working at a distance from the child. I prefer to work close enough to make contact with the child, but avoid taking the shots which would obviously show distortion. I do not consider that the long release coupled with the long focus lens solves this problem as it limits you to shots of the child looking sideways, never towards the camera, and you are also likely to take a number of unintentional self-portraits with this method.

Feet are usually best left out of the picture altogether but a child's hands often *demand* to be included. If he throws them up in delight, or peeps through his fingers at you, or poises a finger on his cheek while he weighs you up, you have only to press the release. But be sure you time it right – he is unlikely to repeat it for you. But if his hands remain limp, 'signifying nothing', we can sometimes jog things along a little.

Put in front of a toddler a table of convenient height and on it a puzzle or a picture-book or a drawing-pad and pencil. He will seldom resist the temptation to turn the pages, to play the game or to express himself artistically. Sometimes we can go still further, even placing his hands in the conventional posed manner of former days. If we were to take the picture now the effect would be rather Victorian. But the modern child does not stay 'posed' long and in no time the hands assume interesting and natural positions. Most professional photographers are aware that the most seemingly impromptu photographs are often the ones that have been carefully contrived.

Retouching

Retouching, beloved by our great-grandparents but rather out of favour today, still has its place in child photography, if in a modified form. It is not suggested that a negative should be covered with stippling on both sides to produce an alabaster complexion effect. But if you are to wait for children to be free of teething rashes, bumps and scratches, you are quite likely to miss some interesting phases. Freckles, which would have all been carefully eliminated at one time, are now considered attractive. Among parents, opinions seem to vary as to whether dribbles and tears should be eliminated. I am for leaving them in. But I feel justified in putting in the tooth that was there yesterday but today is missing.

The miniaturist must do all his correction on the print. Light areas can be filled with a fine sable brush, a number one or two, and a black pigment such as lamp-black or Indian ink. Dark spots must be removed with a sharp-pointed knife, paring the surface lightly until the right density is reached and taking care not to penetrate too deeply. This leaves abrasions on the surface of the print which can be hidden by rubbing on a touch of wax polish or gum if the work is not extensive.

If considerable negative retouching is necessary I substitute a 5×4 in. format camera for my twin lens reflex. But I find that a useful amount of correction can be done on the 6×6 in. square negative with the aid of a magnifying glass.

The retouching desk consists of an easel in which is let a piece of opal glass, illuminated from behind by daylight through a window, or, more usually today, an electric light. My magnifier is on a flexible arm so that it can be positioned over the opal glass at a convenient viewing distance.

A retouching medium, which can be obtained ready made up or mixed from two parts of gum dammar, one part of Canada balsam and eighty parts of turpentine, is applied to the emulsion surface of the negative with a soft cloth or wad of cotton wool and gently rubbed with circular movements. This provides a 'tooth' on which to apply the needle-sharp point of a retouching pencil, the lead of which will be varied according to the density of the negative. Usually an HB is suitable.

The pencil must be handled extremely lightly and the lead applied to the negative with a rhythmic circulating or cross-hatching movement. A light area should be darkened from the centre, working outwards until the density of the surround is reached. A patchy complexion can be 'pulled together' or modelled in this way and from time to time the negative should be studied from further back to assess the overall effect. When even the softest pencil does not give the required density, pigment can be applied in a series of tiny dots with a fine brush, and pin-holes and similar blemishes can be opaqued out in this fashion, resulting in white spots on the print which can be easily stippled out.

Standardizing technicalities

The photographer of years ago was haphazard with his processing at times, developing by inspection and throwing in to his developer a handful of this or that chemical to control the degree of contrast. Nowadays the aim must be to standardize as much as possible – cut out every possible element of chance. When you have just got that 'once-in-a-lifetime' shot of a child, you do not want to be plagued with doubts concerning the technical side of things. Is the lighting balance correct? Is the exposure right? Will the film be over- or underdeveloped? Will it have a full range of tones, with detail in the shadows and the highlights? Will it be too soft or too contrasty?

Consider all the variables. First the lighting. If you use electronic lighting, the intensity, the quality and the duration of the light are constant. You can work at a small enough stop to cover inaccuracies of focus and movement by the child from the focal point.

Film and Developer

Choice of a suitable combination of film and developer is largely a matter of personal preference. For some years I have used a fast film of soft

gradation, tank-developed in standard MQ developer and as this has given me the kind of negatives I want I am reluctant to make any change. With electronic flash lighting the speed of the film is relatively unimportant, so you may prefer to use one of the slower fine grain films. But I stick to my film because it gives a good rendering of a child's skin texture. I find standard MQ a clean working developer which can be replenished and with this combination I have made enlargements up to several feet.

Whatever film and developer you use, most of the technical knowhow you require is on the leaflet supplied by the manufacturers. This, unfortunately, is usually relegated to the darkroom wastebin unread. The recommended development times form a good basis from which to work, but since they must, of necessity, be intended to cover a variety of subjects and conditions and we are taking a specialized subject in standardized conditions, there is room for manoeuvre. Make tests until you have the right kind of negative. Details cannot be given because they vary from studio to studio, but I find that I need to slightly increase the recommended development times, partly because I am using a cold cathode (condenserless) enlarger which needs more contrasty negatives.

The best policy is to experiment, taking only one step at a time, until you feel you have a good, reliable processing routine, then stay with it, with an occasional 'inquest' to ensure that you are not wandering away from your standards. It is a good idea to keep a negative known to be of good printing quality, in the darkroom, with which to compare each new film.

Printing

My prints are made on chlorobromide (white fine lustre, or similar, except when required for reproduction, in which case glossy is used). Any contrast grade of paper other than grade two is seldom needed, and it is wise to aim for the medium grade so that you have contrasty or soft to fall back on, should your negatives vary. I use an automatic-focus enlarger for both 6 × 6 negatives and flat films up to 5 × 4 in. and it has given me good service for many years. Prints are developed in D 163, which gives a pleasing slightly warm image but is clean and practical to use with large quantities.

Development is standard and prints up to 14 × 11 in. are made on a rapid colour processor which produces prints in seven minutes. For printing in colour, the enlarger must have a tungsten light and provision for the

introduction of colour balancing gelatine filters, magenta, yellow, and cyan, in varying densities, preferably above the lens. They are better still positioned above the condenser, where any specks of dust or scratches will not print.

With the printing paper I use for colour, thanks to the standardized lighting, the filter pack seldom has to be changed except when a new batch of paper is used. In that case tests have to be made again. The filter-pack combination for the conditions described usually consists of something like 20 cyan, 70 yellow, and the 2B filter which is always included. A heat-resisting glass must be incorporated in the enlarger to protect the negatives and the filters.

Since development in the colour processing machine is standard, printing exposures must be exceedingly accurate and I have found an enlarger exposure meter to be useful as it allows an assessment of the image on the enlarger easel. I take a reading on a similar highlight in each negative, usually on the forehead just above the bridge of the nose. Working with a constant exposure time the lens is stopped down until a small neon light goes out.

For colour printing it is necessary to stabilize the voltage with a constant voltage transformer. Colour processing has now been brought within the reach of the small studio and the advanced amateur with the rapid colour processors which get rid of the problems of maintaining constant temperatures by using a revolving drum filled with water heated to 100°F. (38°C.). Chemicals are poured into a tray and the special textured surface of the drum picks them up in a fine film. After a pre-soak, the print is held on the drum's surface by a nylon net, so that the chemicals are constantly changed and agitated on the emulsion surface. The chemicals are jettisoned by tilting the tray and half-a-minute's washing must be given between each stage with water which is also heated to within a couple of degrees of 100°F. The stages are as follows:

Stage	Time (min.)
Develop	$2\frac{1}{2}$
Wash	$\frac{1}{2}$
Stop-fix	$\frac{1}{2}$
Wash	$\frac{1}{2}$
Bleach	1
Formaline-fix	$\frac{1}{2}$

Wash	$\frac{1}{2}$
Stabilize	$\frac{1}{2}$
Dry without excessive heat.	

In order to maintain the temperature of the water in the drum to within half a degree of 100°F. throughout the process I have added a small tank and immersion heater, which heats the water and circulates and thermostatically controls it, with great accuracy. The water is pumped into the drum constantly, overflowing back into the tank. This simple device works efficiently and replaces the complicated tank set-up with burst-bubble agitation and the necessity for involved arrangements for temperature maintenance.

Special purpose pictures

Child photographs have a universal appeal, and, although they are usually taken to please the parents, they occasionally have some quality which makes them acceptable to magazine editors or exhibition judges. But it is no longer possible to succeed with merely a pretty picture of a pretty child. The picture must show some originality of treatment, be of a particularly appealing child or have some extra indefinable quality.

Child pictures for advertising purposes are usually of two kinds. Sometimes in the normal course of taking pictures of children for their parents, you are able to catch an unusual expression that fits in well with an advertising slogan. Usually, however, advertising photographs start out as ideas in an ad-man's head. The photographer may be given a sketch from which to work and the greatest difficulty is finding a suitable model. Even with a cooperative model, a long process of trial and error may be involved before anything approaching the original sketch is produced. This is work for the specialist who has a few tricks up his sleeve for inducing suitable expressions. For instance, he may give a baby a drop of lemon juice to induce a grimace.

Darkroom tricks

Exhibition pictures can sometimes be made in the darkroom. It requires a germ of an idea.

A print of a baby holding up its arms was lying on my work-room bench. A member of my staff arranged half-a-dozen pennies in an arc

between the child's hands, and finally we arranged some playing cards on some black velvet, making sure that the lighting corresponded with the lighting on the child and separating some of the cards with pieces of cardboard to create shadows and the illusion of depth. We photographed the cards the correct size, cleared the negative in a weak solution of potassium ferricyanide, positioned this negative on the one of the child and sandwiched the two between pieces of glass. The resulting print, apparently of a child shuffling a pack of cards expertly, was widely exhibited and published. When shown on television a commentator expressed his opinion that it was not a fake!

This technique can be used in many ways. For instance, if you try to photograph a child looking at bubbles, the chances are that no matter how many bubbles are floating about your studio, they will somehow contrive to be missing from the shot with the best expression. But all is not lost. Photograph some glass balls or marbles on black velvet and sandwich the negative with a suitable one of a child as in the case of the playing cards. This time the 'bubbles' can overlap the child – they will appear to be transparent. Several groupings of the marbles can be made so that the most suitable arrangements can be chosen. Other double printing subjects will suggest themselves, such as two shots of the same child, one laughing and one crying.

A final word

Children as we regard them are a comparatively new invention. Victorian photographers usually directed their attention to adults – the famous, the important and the affluent. Children were usually depicted as pocket versions of their elders. Yet sincerity and simplicity shone out from the work of a few portraitists. Technical improvements often resulted in undesirable influences. The dry plate encouraged thousands of photographers of doubtful talents to open studios. Commercialism resulted in an ever-increasing output of stereotyped characterless child portraits.

Hollywood artificialities, the miniature camera with its band of happy snappers (believing that there must be *one* good shot out of thirty-six) semi-automatic portraiture and mass-production, all tended to prevent aesthetic standards keeping pace with technical advances. Today's best workers, aided by technical developments undreamed of by our forebears, extend the old frontiers, stamping the mark of their personality on their pictures. Photography may be said to be a scientific process, yet no two photographers produce the same picture of a child or even *see* him in the same way. Between the birth of a picture idea and its final emergence as a print is a large area allowing individual interpretation. Whether to photograph the child in natural surroundings or in the studio, to let him be aware of the camera or remain oblivious of it, to observe unseen or to control the child in the controlled studio environment, these are the first decisions to be made. But as we have seen, all these methods of approach are capable of producing outstanding child-pictures.

Broadly, there may be said to be seven points for successful studio portraiture of children:

Advance planning
Impeccable technique
Flexible lighting
Favourable atmosphere
Love of children. Patience and the ability to handle them
Cultivation of a 'seeing' eye
Anticipation of the significant moment.

Apart from the points concerning dealings with the child, these requirements also apply to the 'stalkers' and for this method must also be added a spirit of dedication to sustain the photographer during many hours of hopeful observation.

Whatever method is employed the best child photographs will be 'candid' in the sense that at the time of the exposure the child is unaware of the camera. The quest for the crucial moment finally determines the result and brings excitement even to hardened professional photographers, few of whom lose the thrill of anticipation as they examine the latest batch of negatives or transparencies to emerge from the darkroom.

Index